Illustrating the Gospel of Matthew

James E. Hightower, Jr.
Compiler

BROADMAN PRESS
Nashville, Tennessee

4222-43

ISBN: 0-8054-2243-9
Dewey Decimal Classification: 226.2
Subject Heading: BIBLE. N.T. MATTHEW
Library of Congress Catalog Card Number: 81-68044

Printed in the United States of America.

Unless otherwise noted, Scripture quotations are from the King James Version of the Bible.

Scripture quotations from the *New American Standard Bible* (NASB) are used by permission. Copyright © The Lockman Foundation, 1960, 1962, 1963, 1971, 1972, 1973, 1975.

Scripture quotations from *The New English Bible* (NEB) are reprinted by permission. Copyright © The Delegates of the Oxford University Press and the Syndics of the Cambridge University Press, 1961, 1970.

Scripture quotations from the Revised Standard Version of the Bible (RSV) were copyrighted 1946, 1952, © 1971, 1973.

Scripture quotations from the *Good News Bible,* the Bible in Today's English Version are marked (TEV). Old Testament: Copyright © American Bible Society 1976; New Testament: Copyright © American Bible Society 1966, 1971, 1976. Used by permission.

Contributors

Raymond H. Bailey, adjunct professor of Christian preaching, The Southern Baptist Theological Seminary, Louisville, Kentucky

Robert W. Bailey, pastor, Southside Baptist Church, Birmingham, Alabama

Bill Bruster, pastor, Central Baptist Church of Bearden, Knoxville, Tennessee

Harold T. Bryson, professor of preaching, New Orleans Baptist Theological Seminary, New Orleans, Louisiana

James E. Carter, pastor, University Baptist Church, Fort Worth, Texas

Robert D. Dale, professor of pastoral leadership and church ministries, Southeastern Baptist Theological Seminary

J. Daniel Day, pastor, First Baptist Church, McAlester, Oklahoma

Elmer L. Gray, editor, *The California Southern Baptist,* Fresno, California

Jack Gulledge, editor, *Mature Living,* Nashville, Tennessee

Brian L. Harbour, pastor, First Baptist Church, Pensacola, Florida

Robert J. Hastings, editor, *The Illinois Baptist,* Springfield, Illinois

Roger Lovette, pastor, First Baptist Church, Clemson, South Carolina

Alton H. McEachern, pastor, First Baptist Church, Greensboro, North Carolina

Ralph L. Murray, consultant, Sunday School Department, The Sunday School Board, Nashville, Tennessee

James M. Porch, pastor, First Baptist Church, Tullahoma, Tennessee

W. Wayne Price, pastor, Williamsburg Baptist Church, Williamsburg, Virginia

Ernest D. Standerfer, director of stewardship development promotion, Stewardship Commission, SBC, Nashville, Tennessee

William P. Tuck, associate professor of Christian preaching, The

Southern Baptist Theological Seminary, Louisville, Kentucky

Bill D. Whittaker, pastor, First Baptist Church, Murray, Kentucky

James A. Young, chairman, Department of Religion, Louisiana College, Pineville, Louisiana

Introduction

Illustrations, What Are They?

As the editor of *Proclaim,* I travel frequently, promoting and interpreting the journal of biblical preaching to pastors, seminary students, and other preachers. Invariably someone in the group will already be a subscriber. I ask this person, "What is the most useful section of the journal to you?" Routinely the answer returns, "The illustrations, I really use the illustrations." Effective illustrations, those that do not appear to be canned or artificial, are needed by pastors.

Why are illustrations needed? The word *illustration* is derived from the Latin verb *illustrare* which means "to light up." Charles Spurgeon said illustrations are windows that let light into the chambers of the mind. Illustrations help make truth understandable to the hearers. An Arab proverb says, "He is the best speaker who can turn the ear into an eye." *Illustrating the Gospel of Matthew* will help you turn ears into eyes.

Illustrations, Why Use Them?

J. Dixon Free, writing about sermon illustrations, said they should be used for the following reasons.[1]

"Illustrations make a sermon interesting."—Without illustrative material a sermon lacks the living quality it needs. An illustration in a sermon is like an oasis in a desert.

"Illustrations give clarity to the sermon."—They help the congregation to understand the logic and reasoning of the preacher. George Sweazey said, "The manipulation of abstractions can be very satisfying for the preacher because he already knows what he is talking about; he may be aware of an actuality behind the generalities he juggles, but the congregation will not be unless he shows it to them."[2]

"Illustrations help persuade."—Illustrative material helps convince people of the truth. The illustration that is used skillfully can help the

listener see the practicality of the message that is preached. In doing so, the illustration becomes a vital link in the process of transforming a theological truth into a changed way of life for the listener.

"Illustrations help capture the attention."—Oftentimes the illustration may be used for this purpose in the introduction to capture the attention of the congregation at the outset of the message. Illustrations are just as useful throughout the entire message to maintain the attention of the listeners. These word pictures need to be systematically spaced in the body of the sermon to accomplish this.

"Illustrations help break down resistance."—Many truths that are preached are hard sayings. Those teachings which are more difficult to accept and require more commitment on the part of the hearer can be better understood when illustrated.

"Illustrations can be inspiring."—This inspiration can lead the hearer to do that which is good or to avoid doing that which is bad.

"The illustration is a teaching tool."—Repetition is an important method in teaching. A doctrinal truth stated directly in a sermon can be repeated through the use of the illustration. Thus, the illustration drives home the sermonic truth through repetition.

"Illustrations are needed by you and the hearer."

Illustrations, Where Do They Come From?

This book of illustrations is suggestive, not exhaustive. It is always best for illustrations to be devised and owned by you, the preacher. Illustrations are all around you. They can be found in the Bible, the classics, pastoral visitation, pastoral conversations, general reading, personal experience, family experience, and the newspaper. Illustrations are only limited by the imagination of the preacher. However, in seeking illustrative material, the pastor must never betray the confidence of the people. Thursday's pastoral counseling session is never Sunday's sermon illustration!

Illustrations, a Word of Caution

Andrew Blackwood said: "On the shelves of the study leave no room for books of illustrations, even though they come from Spurgeon or some more recent pulpit master. No such man ever clothed his sermons with secondhand garments. Be yourself!"[3]

I disagree. The sin is not in using apt, alive illustrations by

someone else. The sin is in becoming too fully dependent on them. Being yourself does not preclude using the best of someone else. Plagiarism and making someone else's idea your own are not the same thing.

This book is not offered to pastors as a crutch, rather it is offered as a tool in ministry. It must not be relied on exclusively, but it is one resource to add to the wealth of material gleaned from many sources before a sermon is created.

How to Use This Book

This book of illustrations has several unique features to maximize its effectiveness. First, the illustrations are all related to one book of the Bible, Matthew. Second, the illustrations are listed in chronological order from Matthew 1:1 to Matthew 28:20. Third, each illustration is classified by subject. An example of this is Matthew 1:1—Birth. Finally, a subject index is included. I hope these features will aid pastors in their preaching ministry.

JAMES E. HIGHTOWER, JR.
Compiler

Matthew 1:1-17 Genealogy

In New Mexico a great rock guards a pass which opens to the northwest section of our country. This rock wall is called Inscription Rock and is part of a larger formation called El Morro. Inscription Rock received its name in the sixteenth century by the Spaniards who used it as their regular passageway when they traveled into what we now know as the extreme southwest portion of the United States. Many others also used this route. When a soldier of fortune, a lone trapper or prospector, or a traveler would pass through Inscription Rock, he would cut into the rock his name, the date, and the old Spanish expression, *"Paso por aqui."* Translated, the saying means "passed through here." Whether he was heard from again or not, that person on a particular date had passed and left his mark forever embedded in Inscription Rock.[4]

In the genealogy of Jesus Christ, Matthew noted the royal line of the descent of Jesus. Names like Abraham, Jacob, David, and the others had carved their names on the inscription rock of Jewish history. Ancient Jewish Christians saw this not merely as a list of names but as a majestic resounding of the way God worked through his people. The names carved on this inscription rock pointed the Jewish Christians directly to Jesus.

WILLIAM P. TUCK

———◄●●►———

Matthew 1:18-25 Birth of Jesus

Sören Kierkegaard, a Danish theologian of a century ago, told a simple story which illustrates the incarnation. Once there was a prince

who was single and eager to marry a lovely maiden for his future queen. Near the prince's palace was a large city where he often rode in his carriage to take care of various responsibilities for his father. One day he went through a rather poor section of the city. He happened to glance into the eyes of a beautiful maiden.

Within the next few days he returned to that section of the city. He wanted to catch another look at the beautiful maiden. Soon the prince had a strong infatuation with the girl. On one visit he had the good fortune of meeting this young girl. But he had a problem, How should he proceed to marry the young girl?

Of course, he had the authority to order the girl to the palace and propose marriage. But even a prince wanted the girl to want to marry him. Maybe he could go to the maiden's house in his royal dress. Or, perhaps he could masquerade as a peasant and try to gain her interest. After he proposed, he could pull off his "mask."

Finally, a real solution presented itself. He would give up his kingly robe and move into her neighborhood. There he would take up a vocation, say, a carpenter. During his work in the day and during his time off in the evening, he would get acquainted with the people, begin to share their interests and concerns, begin to talk their language. And in due time, should fortune be with him, he would make her acquaintance in a natural way. And, should she love him, he would ask to marry her.

This the prince did. And when the maiden did come to love him, he told her who he really was. In the birth of Jesus, God wishes to join our lives with his in a living relationship so that we may live happily ever after with him.

HAROLD T. BRYSON

Matthew 1:18-25 Interpretation

Several years ago I was called to the hospital in Baton Rouge, Louisiana. When I arrived, I found a confused, lonely, and sick Greek sailor. He had become seriously ill at the Baton Rouge harbor and could not communicate with the doctors.

I went out to the campus of Louisiana State University and found

two Greek students who spoke English fluently. I took them to the sick sailor's hospital room. As soon as they entered the room and spoke to the man in Greek, his face literally lit up. In a short time, the doctors were able to determine the nature of his illness and begin treatment.

This is the glorious message of the incarnation. People were walking in darkness of sin. God seemed so remote. But God took the initiative in the coming of Jesus to a sin-sick world. "Thou shalt call his name Jesus: for he shall save his people from their sins."

The interpretation of the name *Jesus* reminds us that he came to save us from our sins.

JAMES A. YOUNG

Matthew 1:21 Name

Harry L. Hopkins was special assistant to President Franklin D. Roosevelt and traveled with him to the famous Yalta Conference in 1945. During the historical event when the leaders of the three most powerful nations in the world met, Hopkins obtained the signatures of Winston Churchill, Joseph Stalin, and Franklin D. Roosevelt on a ruble note with an exchange rate of ten dollars at that time. Hopkins got the autographs for his teenage son.

In 1981 the ruble bank note was auctioned for five thousand dollars to a private collector from Minnesota. It is a rare twentieth-century autograph and believed to be the only document bearing the signatures of the three dignitaries.[5]

The combined power of these three world leaders changed the course of history. Even today their names have value. There is another name that has far greater value, and his power has influenced the course of human history for two thousand years. The angel announced to Joseph, "Thou shalt call his name Jesus: for he shall save his people from their sins" (Matt. 1:21). He has been given all power in heaven and in earth (Matt. 28:18), and it has not diminished or been passed on to another.

JACK GULLEDGE

Matthew 2:1 Birth

We have a ceramic nativity scene that we have had for years. Each year during the Christmas season it occupies a prominent place in our house.

As we began to decorate for Christmas one year, I was dispatched to the attic to bring down the boxes with the nativity scene. Then I began to unpack the boxes. I pulled out the wooden stable, then the camels, sheep, and donkeys. Next I located the Wise Men, shepherds, angel, and Joseph and Mary. The manger crib was found. But no Christ child came forth. All of the figures were present except the Jesus. We thought that perhaps in the packing and move he had been lost. It would be terrible to have a Christmas nativity scene without the Christ.

So I began to go through each piece of packing paper that had wrapped the figures. Somewhere toward the bottom of the box I found the baby Jesus figure in the packing paper. Jesus had been lost in the wrapping.

This incident was not the only time in a Christmas season that Jesus has been or will be lost in the wrapping.

Actually, it isn't too unusual to have a Christmas scene with Christ missing from it. Even though the holiday and the season derive their name from the Christ, he is often missing from the scene. The wrapping of Christmas often appears to be more important than Christ.

In the excitement of parties and banquets, the pressure of schedules, the difficulties of shopping, the overrunning of budgets, and the "he got me something I must get him something-of-equal-value" syndrome, Jesus can be lost in the wrappings.

A Christmas without Christ is no Christmas. He always serves to balance our lives, to correct our values, and to remind us of the eternal in the midst of the temporal.

Carefully check your own mental Christmas scene. Make sure Jesus is present in it. Don't allow the Christ of Christmas to be lost in the wrapping.

JAMES E. CARTER

---•••---

Matthew 2:1-11 Birth

During the Christmas season several years ago, my family and I passed a manger scene displayed on a church lawn as we drove to our church to worship. On the Sunday following Christmas, we drove past the same church and noticed that the manger scene had been removed. Our youngest son, Bill, who was a preschooler then, observed: "They have put the Lord Jesus away for another year."

Too often that is exactly what we do. During the Christmas season, people can talk easily about the birth of Jesus and the incarnation. But as soon as Christmas is past, we put that theme away for another year. No one can understand all the mystery and wonder involved in the birth of Jesus and the incarnation. Our attention, however, needs to be focused on its sense of wonder throughout the whole year and not for just a few days during the Christmas season.

WILLIAM P. TUCK

---•••---

Matthew 2:1-12 Christmas

I recall one childhood Christmas that almost got lost for my family and me. The tradition at our house included an early bedtime for the children, after which our parents set up the tree and set out the toys. It was to have been Santa's doing! The Christmas I remember best had a twofold significance. First, I was allowed to stay up and help, having figured out the scheme. Second, the toy upon which most of the excitement was to have hung had to be wound up, as in the days predating batteries. It cost so much that it was to have been a shared toy. When the whole exhibit was in readiness, we discovered that the windup key was lost. No key, no celebration! It was that simple. Mom, Dad, and I took flashlights and went outside where all the boxes and paper had been discarded. We searched every single container. At long last, we found the key and saved the day. It was literally the key to Christmas. And Christmas, as mixed up as it was, almost got thrown out with the trash.

For many of us, the key to Christmas is, indeed, no more than a toy; within a few weeks, many toys have become trash and are cast aside. But for those to whom the Christ has, indeed, come, the key to Christmas is worship. It is the Magi kneeling before the Christ child and honoring him with gifts. Without that worship, there is no Christmas, no matter how elaborate the toys.

W. WAYNE PRICE

Matthew 2:11-23 Christmas

The day after Christmas is one of the less notable days of the year. Fatigue, clutter, broken toys, and unpaid bills characterize the day. Celebration of life quickly reverts to confrontation with life. A similar shift in spirit followed the birth of Jesus. The quiet reverence of Bethlehem was displaced by a hurried flight in the night for safety in Egypt. The song of the angels gave way to the cry of mourning mothers. The birth of the King brought the troops of another king.

Jesus was both celebration and confrontation in a real world of sin. His presence enables us to confront the hard realities of life and to have the experience of Mary and Joseph, "The angel of the Lord encampeth round them that fear him, and delivereth them" (Ps. 34:7).

BILL D. WHITTAKER

Matthew 2:11 Giving

At Sunday School a little boy heard about the significance of Mother's Day and how a person could honor his mother by giving her a present. The teacher had the boys talk about what they could give or do that would please their mothers.

As soon as the little boy got home, he went out into the backyard where some dandelions were growing. He picked a handful and took them to his mother.

His mother knew, of course, that dandelions were only weeds. She

could have rejected them and scolded him, but she saw the significance of the gift and the intention behind it.

She did something that the little boy remembered years later and understood the meaning of what she had done.

She knelt and hugged him. Then she put the dandelions in a vase and placed them in the center of the table she was setting for the Sunday dinner.

The mother had seen in the child's gift more than a handful of dandelions. She accepted it for the intention behind it and honored it in such a way that her action had growing significance to the man that the little boy became.

We are like the Wise Men and the wise little boy when we give to the Lord in a way that expresses our love for him. As we give at the highest level of our understanding and ability, God will accept our gifts and show us through his response how we can give and serve him even better.

ELMER L. GRAY

Matthew 2:23 The Shadow of the Cross

The silent years in Nazareth marked the time where Jesus grew up, learned and practiced the carpenter's trade. As a grown man and the eldest of the children, he earned a living by the sweat of his brow. The artist Holman Hunt has depicted an ominous image in his painting of Jesus in the carpenter's shop in Nazareth. In the painting "The Shadow of Death," the young carpenter, Jesus, rises from a cramped position at the work bench and stretches out his arms to relax them. As he does this, he casts on the wall behind him the shadow of a cross. His mother, Mary, is standing nearby, and her face is filled with terror as she sees the alarming outline of the cross. Could it be that Mary was remembering the words of the aged Simeon who had prophesied that "a sword will pierce through your own soul also" (Luke 2:35, RSV)?

In the wilderness temptations, Jesus had rejected at the beginning of his ministry the way of material means, spectacular methods, and unworthy motives to bring about his kingdom. The shadow of the cross

hung over him from the beginning of his ministry. Soon the time would come, and he would set his face like flint to go to Jerusalem to die (Matt. 20:17-19).

WILLIAM P. TUCK

------------◄•●•►------------

Matthew 3:1-12 Preparing for God

Samuel Beckett wrote an interesting play which he called *Waiting for Godot*. The entire play deals with two disheveled tramps who spend their aimless time waiting for a character called Godot. Beckett probably used the word *Godot* as a synonym for God or some other being. Nonetheless, the tramps wait for Godot because they expect him to explain life to them and to bring an end to their insignificance. Every day a child comes to the characters and informs them that Godot will not arrive until tomorrow. But he never comes to the tramps.

The character John the Baptist came to a waiting world preparing the way for the visit of God to earth. God did come in Jesus, and he explained the meaning of life and delivered human beings from insignificance.

HAROLD T. BRYSON

------------◄•●•►------------

Matthew 3:13-17 Approval

Sam Keen is a struggling searcher. His writings are usually brutally honest, especially about himself. He questions life, and no scrap of meaning escapes his analysis and interrogation. But he is both cognizant and appreciative of those influences which have made him what he is. Reflecting on his personal pilgrimage, he commented concerning the feeling of approval he received from his dad: "Life in the ambience of my father was exciting, secure, and colorful. He did all of those things for his children a father can do, not the least of which was *merely delighting in their existence*"[6] (author's italics).

Such approval was the same received by the Son from the Father.

The Father declared, "This is my beloved Son, in whom I am well pleased." It is acceptable to render the verse, "This is my beloved Son in whom I take great *delight*." Jesus lived his entire life by the total approval of the Father. Numerous people today live limited lives because they have never experienced the feeling of being approved.

JAMES M. PORCH

Matthew 3:16-17 Sonship

James George was born in the Kansas City, Missouri, maternity home in 1947 to a mother who never saw him. The infant was immediately adopted by a Tulsa couple who gave him his name and a life so satisfying that he never thought to look back. In July 1980, George discovered that he had myelocytic leukemia. The doctors told him he could expect to live only about forty months unless he got a bone marrow transplant from a matched donor, preferably a blood relative. But George had no idea who his relatives were.

George took his case to court to discover who his biological parents were so that he might get a blood donor. Missouri has a law prohibiting such information to be made public. James never found out who his parents were, but he received information from his mother saying, "I do not feel he is my son. . . . I was told I would never know who adopted the child even if I wanted to."[7] Her indifferent attitude toward her son is in marked contrast to the proud claim of the Father on Jesus.

BILL BRUSTER

Matthew 3:17 Pride

During the last illness of the mother of Harry S Truman, a chaplain visited her. Hoping to cheer her up, he said, "Mrs. Truman, you must be very proud that a son of yours is in the White House."

After thinking for a minute, she said, "Well, yes, but I have got

another son who lives down the road—and I'm just as proud of him."[8]

God, too, is pleased with his Son. At the baptism of Jesus, the heavens opened and a voice said, "This is my beloved Son, in whom I am well pleased."

JACK GULLEDGE

Matthew 3:13-17 Baptism

A man stepped out into a busy intersection. He wore a uniform and a badge, and people recognized what he was and what he intended to do. He had come among them in a time of confusion and danger and had the authority and ability to help them. He was a police officer.

Jesus came to a world of need. He joined the crowd of people coming to John to be baptized. Why did Jesus at the beginning of his ministry present himself to be baptized? W. T. Conner said: "Truly he did not belong with them so far as personal sin was concerned. But by his own choice he took his stand with them as much as to say that vicariously he was making their tragic lot his own."[9]

Jesus joined the line of sinners waiting to be baptized by John in order to identify with them and also to prophesy that he would die for them and save those who would accept him.

Jesus became the head of the line for all who would follow him in faith and show by their baptism that they were accepting his authority and responding to his leadership. Jesus joined the human traffic not to participate in the disorder but to take charge and direct people in orderly living.

Our baptism is somewhat like his. In his baptism he joined us to show he had come to die for our sins and to rise to take charge of our lives. In our baptism we show that we accept his death and resurrection as effective for us. We are buried in baptism to show that in Christ we are dead to sin, and we are lifted up from the water to walk in the newness of life and to show our hope of resurrection to a glorified life with Christ forever.

ELMER L. GRAY

Matthew 4:1-10 Temptation

The designers and makers of airplanes test their products in wind tunnels. Wind tunnels are built in various shapes and sizes in order to test different aspects of planes. The test can show the weaknesses that need attention, or it can prove the strength and soundness of the plane. Temptation is somewhat like a wind tunnel, both in Jesus' case and in ours. The temptations of Jesus demonstrated that he could survive without the devil's help, he could reach people without using the devil's tactics, and he could be victorious without accepting the devil's values.

ELMER L. GRAY

Matthew 4:3 Self-Knowledge

Whatever Satan's use of the phrase "If you are the Son of God," meant, it is clear that Jesus' self-understanding was being tested. The tempter is always at work, trying to undermine our knowledge of who we are and who we are called to be. As E. Stanley Jones illustrates, a wrong idea of who we are can lead to disaster.

"In a small mission plane I went over the spot in Zambia, Africa, where Hammarskjöld met his tragic death. The pilot of the mission plane, who lived in Zambia, told me that they found in the wreckage of the U.N. plane the open map of Nadolo, a town in a section near Leopoldville, Congo, instead of the map of the city of Nadola, Zambia, the destination of the plane. The map of the Nadolo section showed that the pilot had a thousand feet more than he actually did have in landing at Nadola, for Nadola is higher than Nadolo. So he crashed in an open field in the night, thinking he had a thousand feet more than he actually had. He had the wrong map. The difference of an 'o' and an 'a' was the difference between death and life—and a very precious life.

"If you have the wrong mental map of your self, you will probably come to wrong landings, a disaster instead of a destination."[10]

J. DANIEL DAY

Matthew 4:3-4 Values

A handsome twelve-year-old boy in our church suddenly began to have severe headaches. His parents took him to the doctor, and he was admitted to the hospital for a series of tests.

After several days of extensive tests, the doctors determined the boy had a very large and dangerous brain tumor. Surgery was absolutely necessary.

I waited three long hours with a worried mother and father while their son was in surgery. The doctors had painted a very grim picture of the boy's condition and of his chances of survival. Even if he lived, the doctors were very concerned about his mental capacity.

During those three hours, we talked and prayed. Finally the conversation led to a discussion of the ultimate values of life. The father wisely remarked, "At a time like this, we realize the real values of life."

I thought of Jesus' words to Satan during his temptation. "Man shall not live by bread alone." Jesus did not say man does not live by bread. He said, "Bread alone." There are other matters in life which demand our attention as surely as providing bread for our families. We must be aware of our spiritual as well as our physical needs.

JAMES A. YOUNG

Matthew 4:4 Bread

In *Back to Methusaleh,* George B. Shaw has Adam confess to Eve how flat the one-dimensional life can get:

> If only there may be an end some day, and yet no end! If only I can be relieved of the horror of having to endure myself forever! If only the care of this garden may pass on to some other gardener! If only the sentinel set by the Voice can be relieved! If only the rest and sleep that enable me to bear it from day to day could grow after many days into an eternal rest, an eternal sleep,

then I could face my days, however long they may last. Only there must be some end; some end. I am not strong enough to bear eternity.[11]

That quality of flatness of life comes when it is lived in the absence of the Living Presence.

Was Jesus speaking to that flatness of the one-dimensional life when he answered the tempter after his second temptation? You will recall that he hearkened back to Israel's wilderness experience and recalled the lesson of the manna: "Man shall not live by bread alone, but by every word that proceeds from the mouth of God" (Matt. 4:4, RSV).

Taken in its historical context, as found in Deuteronomy 8, Jesus' word means that we, like Israel in the wilderness, must learn that even our bread comes from God. When we learn that lesson we are ready to live.

RALPH L. MURRAY

Matthew 4:6 Discipleship

The one sermon which more people would rather hear is what Satan "preached" to Jesus when he tempted him to jump from the Temple since angels would "bear thee up, lest at any time thou dash thy foot against a stone."

We like to be reassured that if we follow the Lord, all our problems will melt into thin air. True, God promises many resources for his people. But he doesn't promise us *carte blanche* from all trouble. Even Christians bruise their knees when they stumble on rocks!

Ralph W. Sockman spoke to this in his book, *The Whole Armor of God*. "We think the church will appeal to people more if we stress what it *offers* rather than what it *requires*. . . . Whereas the first followers of Christ often had to forfeit business opportunities, some pulpits now proclaim that to follow Christ will mean financial success. Prayer is often advocated as the way to get what you want of this world's goods.

. . . The tendency of the modern church is to take out the cross and put in cushions."[12]

<div align="right">ROBERT J. HASTINGS</div>

Matthew 4:18-22 Called

One warm spring afternoon Platus Iberius Lipsey, revered and respected history professor of Mississippi College, was lecturing on Martin Luther. Lipsey's Reformation lectures, sermonic in nature and delivery, were always inspirational. Ministerial students were guaranteed at least one sermon idea each class session. That special afternoon the professor seemed to transport us back into sixteenth-century Germany. He narrated in polished rhetoric Luther's life, giving particular attention to the young monk's struggle between the burden of his sin consciousness and his dawning belief in righteousness by faith. Lipsey made Luther come alive.

Following the class session, a group of students with pressing questions crowded around their erudite professor. One of the inquirers asked, "Professor Lipsey, did you ever think you were called to preach?"

He replied, "My mother called me to preach, my father called me to preach, my brothers and sisters called me to preach, but the Lord did not call me to preach." Then he paused but soon continued, "But sir, I have a calling, I've been called to be a Christian, and that is all the responsibility I can bear."

Jesus' first invitation to his disciples was "Follow me." Without question, such responsibility is sufficient for all of us.

<div align="right">JAMES M. PORCH</div>

Matthew 4:19-22; 19:27,30; 20:16 Discipleship

In *Jesus Christ Superstar,* Tim Rice has the apostles at the Last Supper admit, somewhat disillusioned, that their idea of discipleship

involved fame and probably fortune. The setting and the future prospect, however, have set that aside. They are trying to get psyched up for Jerusalem and the events Jesus has predicted will take place there.[13]

We do not like the sacrilege of Rice's lyrics, but what about his insight on the apostles? Their motivation is worth a second look. The story of the Gospels suggests that apostleship was not a "they lived happily ever after" kind of tale. Although Matthew 4:19-23 seems to indicate an immediate, even spontaneous and sacrificial devotion to Jesus by Peter, Andrew, James, and John, later passages tell another story. Hear Peter ask, "Lo, we have left everything and followed you. What then shall we have?" (Matt. 19:27, RSV). After Jesus spoke to their question, perhaps with a twinkle in his eye, as though they could count on their wildest dreams' fulfillment, he went on to tell a story with a strange punch line. You may recall it: "But many that are first will be last, and the last first" (Matt. 19:30; 20:16, RSV). In fact, that line appears twice: before and after the wages and hours parable (Matt: 19:30 to 20:16).

Still later the disciples learned that to follow Jesus one must set aside his own self, including the instinct to save one's life. They were surprised at that (it was much different than they had imagined). But—to borrow C. S. Lewis' phrase—they were "surprised by joy." They learned that disciples may not come to fame and fortune, but they do come to fulfillment.

Is it different for us? Albert Schweitzer concludes *The Quest of the Historical Jesus* with words radiant with beauty and laden with truth: "Jesus comes to us still as One unknown, as of old he came by the lakeside to those who knew him not. He speaks to us the same word, 'Follow me,' and sets us to the tasks he would fulfill in our times. He commands, and to those who obey him, be they wise or simple, he will reveal himself in the toils, the conflicts, the sufferings through which they shall pass in his fellowship, and as an ineffable mystery, they shall learn in their own experience who Jesus is."[14]

RALPH L. MURRAY

Matthew 5:1-10 Happiness

The lady was sitting with her husband at the football game. The people sitting behind her had spilled their beer on her. She was sick on the popcorn. Her team was forty points behind, and she was freezing to death. Shivering, she turned to her husband and asked, "Honey, tell me again how much fun we're having."

What a picture of many Christians in the church today. They know they are supposed to be happy, but joy has escaped them. From the beginning, joy has been a product of Christian faith, not the kind of happiness that is based on pleasant circumstances but a deep joy that is not controlled by the circumstances. Christian joy is a joy that comes from within.

How can we experience that deep happiness? Jesus answered that question in the first verses of the Sermon on the Mount. Exchange the word *happy* for the word *blessed,* and you will have an outline of the basic qualities of character that will lead to a deep, abiding joy in your life. Happy is the man who knows Christ and follows his pattern for living.

BRIAN L. HARBOUR

Matthew 5:1-12 Happiness

Sydney Harris, a syndicated columnist, once commented that no one he had ever known who was really happy had made happiness a goal in life. He observed that it seemed to be a by-product of some other deep commitment to a goal outside of the person's life.[15]

This truth is communicated through the Beatitudes. Jesus says that happiness comes to those who cultivate and experience distinctly Christian attitudes toward life. Happiness results from disciplined living under the lordship of Christ.

ERNEST D. STANDERFER

Matthew 5:3 Humility

To be poor in spirit does not mean that one has a poor spirit about him or that he is dispirited and discouraged. It means *humility* in the better sense of the word. It means that persons recognize their spiritual poverty but refuse to despair over that fact. Instead, they keep reaching out and expecting better things. That's why Jesus labels such persons as "blessed."

Here are some good definitions:

"Christian humility is attained by aiming at the highest we know with the utmost we have"—Ralph W. Sockman.

"I believe the first test of a truly great man is his humility"—John Ruskin.

"Lord, make me humble, but don't let me know it"—Dwight L. Moody.

"Beware of the pride of humility"—Jerome.

"By Jesus' standard of greatness, it is necessary to climb down to the top. It is essential to be lowly in order to be lofty. It is imperative to stoop to conquer"—J. E. Lambdin.[16]

ROBERT J. HASTINGS

Matthew 5:4 Compassion

When Jesus taught that those who mourn are blessed, he meant more than sorrow over personal losses. He also included those who are concerned and grieve over the greater problems of humanity.

John R. McFarland, who once served as campus minister of the Wesley Foundation at Normal, Illinois, tells about an eye-opening summer he worked in the slums of Chicago, while a college student himself. At the time, he was also serving as pastor of a small rural church.

In the fall, when he returned to his congregation, he told how the squalor and crime of the city had given him inner pain. After the service, a retiree told McFarland that he had allowed himself to get too upset. This retiree, who once lived in Chicago and served as chairman of the board of one of the nation's largest corporations, said, "Don't

worry about it, John. You'll get to the place where that sort of thing won't bother you any more." Christian compassion never "gets used to" suffering, in any form.[17]

ROBERT J. HASTINGS

Matthew 5:4 Comfort

In her book, *The Rebecca Notebook and Other Memoirs,* celebrated author Daphne du Maurier tells of coping with the death of her husband. "As the months pass and the seasons change, something of tranquility descends; and although the well-remembered footstep will not sound again, or the voice call from the room beyond, there seems to be about one in the air an atmosphere of love, a living presence. . . . It is as though one shared, in some indefinable manner, the freedom and peace, even at times the joy, of another world where there is no more pain. . . . When Christ the Healer said, 'Blessed are those who mourn, for they shall be comforted,' he must have meant just this."[18]

BILL D. WHITTAKER

Matthew 5:5 Meek

The meek are not the mousy. The meaning of this word has changed across the years. The Greek word means "tamed." Martin Luther translated it "the sweet-tempered" and *The New English Bible* calls the meek "those of a gentle spirit." The French translation is "the debonair"—God's gentle people.

The word *meek* really describes persons who have self-control and self-discipline. Only two men are called meek in the Scriptures: Moses, the mighty lawgiver, and Jesus, the Son of God. Neither were mousy personalities. They were men who lived under God's control. The mighty meek are the God controlled.

ALTON H. McEACHERN

Matthew 5:9 Peace

Traditionally, war has drained more of our attention, more of our lives, and more of our material resources than has peace. If humanity, through the years, had spent more energy following Jesus' suggestion to be peacemakers, much of the fear and threat of war would be nonexistent.

One of the finest statements on this issue was made in a 1948 Memorial Day address by the late General Omar Bradley, of World War II fame. Speaking at Long Meadow, Massachusetts, the general said: "We have too many men of science, too few men of God. We have grasped the mystery of the atom and rejected the Sermon on the Mount. . . . Ours is a world of nuclear giants and ethical infants. We know more about war than we know about peace, more about killing than we know about living."[19]

ROBERT J. HASTINGS

Matthew 5:9 Peace

What is peace? It is not simply the absence of strife. If so, Rip Van Winkle would have been the happiest mortal in literature (during his twenty-year nap).

Buddhism equates peace with tranquility. It would envision peace as one person alone in a quiet meadow. Christianity sees peace as all humankind together, with God as acknowledged Lord. This is a much more positive kind of peace.

Peace is not appeasement and compromise with evil. Peace at any price is not worth what it costs.

Peace is a positive good. It grows out of right relationships with God, with other persons, and oneself. Peace is the gift of God—a fruit of the Spirit.

The peacemakers are those who *bring people together,* and *bring people to God.* Little wonder they are called the children of God.

ALTON H. MCEACHERN

Matthew 5:9 Peacemakers

My two children, who were then five and seven years old, were sitting on the floor one Saturday morning in January 1973, watching the parade of cartoons on TV. Suddenly the cartoons were interrupted as stately men gathered around a huge table to sign the Vietnam peace agreement. My children looked up at me and asked, "Daddy, what is war?"

I paused to look at innocence and childhood who did not yet know the pagan god, Mars. The wonder of it fascinated me. Our age is too familiar with "wars and rumors of wars." To be peacemakers is to be Godlike because we are sharing in his work. The blessedness of the peacemaker is to be engaged in the ministry of reconciliation. What a marvel to live in a world without knowledge of war! But that dream has not yet been realized. The peacemakers are called blessed because, like their eternal Father, they are waging peace in the world.

WILLIAM P. TUCK

Matthew 5:12-14 Light

During the fall of 1965, a friend was studying in New York City when the first great power failure occurred in that metropolitan area. He had experienced power failures before but never on such a scale as that. He related the strangest feeling he had was to see the city from his vantage point and suddenly realize the whole area was totally dark! Darkness is awesome and frightening when we have little or no way to overcome it.

Jesus' hearers had a knowledge of darkness that was more intense than ours. They knew what it was to live in a land in which all kinds of crime and evil went on during the darkness, a nightly blackness that was relieved only by the carrying of a small oil light. The Jewish hearer did not think of light as something which penetrated into darkness but as the power which overcame and conquered darkness.

Jesus said that his followers are to be the light of, the light for the world. The sad reality is most church members have failed to avail themselves of his vast resource of power and light. We are not the light, but we are to be reflectors of the true light. Philip B. Bliss expressed

this thought in a hymn which described an experience he had. In a storm-tossed ship trying to make the harbor, the pilot saw the lighthouse with welcomed feelings. But many of the smaller harbor lights along the rocky shore line were not lighted, so the entrance into the harbor was treacherous and dangerous. The refrain of Bliss's song urges:

> "Let the lower lights be burning!
> Send a gleam across the wave!
> Some poor fainting, struggling seaman,
> You may rescue, you may save."[20]

You are the lower lights the world needs. You do not bring people to salvation, but you can point the way to the Redeemer when you become willing to reflect Jesus Christ in your life.

ROBERT W. BAILEY

Matthew 5:14-16 Light

Clarence Jordan's *Cotton Patch Version of Matthew* translates this passage: "You all are the world's light; you are a city on a hill that cannot be hid. Have you ever heard of anybody turning on a light and then covering it up? Don't you fix it so that it will light up the whole room? Well then, since you are God's light which he has turned on, go ahead and shine so clearly that when your conduct is observed it will plainly be the work of your spiritual Father."[21]

Contrast this with Lady Macbeth's contemplating the murder of King Duncan:

> "Come, thick night,
> And pall thee in the dunnest smoke of hell,
> That my keen knife see not the wound it makes,
> Nor heaven peep through the blanket of the dark,
> To cry 'Hold, hold!' "[22]

ALTON H. McEACHERN

Matthew 5:16 Saints

A small boy traveled extensively throughout Europe with his parents. In their travels they visited many beautiful cathedrals. Sometime later he was asked to define a saint. He thought and then remembered the pictures of "saints" he had seen on cathedral windows. He explained, "A saint is someone who lets the light come through."[23]

Followers of Christ are to "let the light come through" by their good works. The lives of Christians are to radiate the presence of Christ in order that unbelievers will be drawn to him who is the Light of the world and bring glory to God.

ERNEST D. STANDERFER

Matthew 5:38-39 Retaliation

Like many infants, my twin sons went through a period of biting their playmates and, most often, one another. Needless to say my wife and I were horrified at such cannibalistic behavior coming from our perfect progeny. For some now-unremembered reason, we accepted the counsel of some veteran mother: "If you want to break them of biting, just bite them every time they chomp down on another child." It seemed a bit cruel to do, but we were desperate to break their habit. So we began leaving our own teeth marks on their little hides each time they bit someone, being careful always to tell them that they were hurting other people in the same way when they bit them.

One day, while driving to church, one boy took a plug out of the other's arm. Since I was in the front seat I couldn't easily get to the offender to bite him back. So I scolded him, "No, no, no! We never, never bite!"

Whereupon, my wife, who was deeply suspicious of the whole method, said, "Do you realize what you just said? For a family that 'never, never' bites we're sure doing a lot of it!"

"Biting back" is seldom, if ever, a productive tactic. We tell ourselves we will teach the offender a lesson by our retaliation. In fact, we're only succumbing to his childish ways.

J. DANIEL DAY

Matthew 5:43-48 Love

In northern Uganda, Africa, there is a tribe known as Ik. Sociologists feel that in a few years this tribe will no longer exist. The reason for the tribe's decline is their selfish orientation to living. The people of the tribe live entirely for themselves. At the age of three, each child is put out of the home in a desperate struggle for the "survival of the fittest." One anthropologist, who has studied the Ik tribe carefully, reported that there is no one in the tribe who remembers an act of kindness. These people have become selfish animals. They have lost their capacity to love—to care for one another. They are dying humanly. To live is not just to exist. To live is to love in meaningful ways with other people.

HAROLD T. BRYSON

Matthew 5:48 Perfection

Carl Bates, respected pastor and seminary professor, once wrote about an experience of Michelangelo as related by a tour guide. The great artist was explaining his current work to a visitor. He pointed out how he had retouched one part, softened certain features, given more expression to a muscle, and more energy to a limb. The visitor commented that those things seemed to be mere trifles. The master replied that it was trifles that made perfection, and perfection was no trifle.[24]

Striving for Godlikeness brings tension into Christians' lives, but it is a tension that is needful and productive. Perhaps, as Michelangelo indicated, growing into what God wants us to be does not come by large leaps but by careful attention to the seemingly trivial activities and responsibilities of life.

ERNEST D. STANDERFER

Matthew 5:48 Role Models

When Jesus challenged his disciples to "be ye therefore perfect," he pointed to the "Father which is in heaven" as their role model. For the Christian, perfection is the long-term, lifetime goal. When we measure ourselves by lesser standards, our quest is watered down considerably.

Writing in the November 1977 issue of *Reader's Digest,* Allen Dixon of Columbus, Ohio, tells how his father, a TV repairman, had neglected to fix an antenna on his own home, after a windstorm ripped off one arm.

When a new family moved in next door, the man of the house decided to install his own antenna. Knowing his neighbor was a TV repairman, he felt his antenna would be a good guide to go by. So he drilled the lead-in hole in the same location, then turned the antenna in the same direction. Finally, studying his neighbor's roof one more time, he reached up and yanked off an arm of his brand-new antenna![25]

The moral is that if perfection is our goal, we'd better find a perfect model. And our Heavenly Father is the only one who fills the bill.

ROBERT J. HASTINGS

Matthew 6:1-6 Hypocrites

The word *hypocrite* is a difficult word for translators of the Bible to describe. But nearly all use the idea of deceit.

The Indians of Latin America refer to hypocrites as persons with "two faces," "two hearts," "two heads," and "two sides." A man with "a straight mouth and a crooked heart" characterizes the hypocritical person to the Thai people. In Madagascar, a hypocrite is a person who "spreads out a clean raffia mat." The mat is how the negligent housekeeper hides a dirty floor.

Duplicity is an obvious ingredient in hypocrisy. Abraham Lincoln told of a man who murdered both his parents, and, then, when sentence was about to be pronounced, begged for mercy on the grounds that he was a helpless orphan!

ROBERT D. DALE

Matthew 6:5 Hypocrite (Prayer)

"A hypocrite," says Oren Arnold, "is a man who writes a book praising atheism, then prays that it will sell."[26]

JACK GULLEDGE

Matthew 6:7-15 The Lord's Prayer

During the years of World War II, Helmut Thielicke, the great German preacher, tells that as Hitler gained more and more power he had to stand up each Sunday and preach to his people. Always the upturned faces of his people asked the same question: *Where are we to turn? What are we to do?* And Thielicke tells that during the horror of the air raids and the declining days of a reign of terror, followed by the military and political collapse, and the beginning of the occupation, he began to preach on a single theme. Before the series was finished, the congregation was forced to abandon their church for a smaller auditorium. Their old, magnificent church building had been demolished by the falling bombs. Sirens sent the worshipers scurrying. Amid faces of doubt, despair, hunger, and thirst, Thielicke found a word of encouragement. He chose the simple words of the Lord's Prayer. Week after week people gathered again and again to find hope and meaning for what they had to do. He writes that he found the Lord's Prayer adequate for such a time as that. The Lord's Prayer became a life raft that kept them going.

ROGER LOVETTE

Matthew 6:11 Brotherhood

George Buttrick once said, "'Give us this day our daily bread' is good theology and good table manners. Earth is a giant banquet table;

and all men are members of one family. Part of learning to pray this is learning how to pass the bread from our Father to our brothers."[27]

BILL D. WHITTAKER

Matthew 6:19 Treasure

Dr. Joe Ingram wrote about an old man in a rest home. One day his pastor visited him and the old man said, "You know, pastor, I'm rich! When I was in business I had a strong box for my valuables. Now I have another box, and I would like to have you read to me some of the documents in it." The elderly man then pointed to the Bible and told his pastor that the Bible was his strong box. He asked his pastor to open the Bible to John 3:16 and read of his pardon. He then asked for a document on his sonship to be read from Romans 8:15. Another valuable was his life insurance as recorded in 1 John 2:25. He wanted to hear about his fire insurance found in 2 Peter 3:12,13. He asked his pastor to read his will from John 14:2,3. After his pastor had finished reading the old gentleman said, "I'm a big stockholder. I'm rich."[28]

BILL BRUSTER

Matthew 6:19-21 Stewardship

Once two wealthy Christians, a lawyer and a businessman, were on a round-the-world tour. In Asia they saw a boy pulling a crude wooden plow while an aged man guided it through the rice paddies. The lawyer, surprised at the sight, took a picture and said they must surely be poor. His guide told them the family was poor and after the war they wanted to help rebuild their church that had been destroyed. Since they had no money, they sold their ox and pulled their plow themselves. The businessman quickly noted they must have really made a sacrifice. He was promptly corrected with the response that they called what they did an opportunity—they felt fortunate they had an ox to sell!

Those two men returned to America and more than tripled their contributions as they began to give their tithe to their church. In addition they asked their pastor for some plow work to do! They had never really given of their money before to help others know about Christ. They had never used their influence to enable someone else to know about salvation. They had not used their opportunities to make an impact on the life of another for the sake of Christ. Now they knew the joy of treasuring what was truly important in life. Now they recognized the joy of receiving spiritual blessings through the giving of their best to Christ.

We need not go to a strange land and see surprising things to allow God's Spirit to move us to be the kind of stewards Christ has called us to be. We can learn right now to put our treasure in the hands of God and know that our heart is in the right place!

ROBERT W. BAILEY

Matthew 6:19-21 Earthly Treasures

A man once went to a wealthy citizen to obtain a donation for a community project. The man refused to give anything, citing that he could not afford it. As the solicitor departed, he said, "Joe, if you are not careful, you're going to be the richest man in our cemetery."[29]

Jesus warned against accumulating earthly treasures, especially at the expense of spiritual treasures. The accumulation of earthly treasures, material things, as ends in themselves, is sheer folly. Jesus challenged us to invest our time, abilities, and financial resources in concerns that help people and please God.

ERNEST D. STANDERFER

Matthew 6:19-21,25-34 Money

John Wesley, one of the truly remarkable Christians of all time, lived quite simply. His example seems an accurate demonstration of

Jesus' admonitions about priorites and material things. Wesley tried to save all he could and give away all he could. When he was a student, his annual income was thirty pounds (less than one hundred dollars). He lived on twenty-eight pounds and gave two pounds away. When in later years, his income increased to more than one hundred pounds, he continued to live on twenty-eight; he gave the rest away.

W. WAYNE PRICE

Matthew 6:19-21,33 Materialism

"What you own, owns you," is a slogan used by a large insurance company in its advertising campaign. The sad thing about the slogan is that it is true for many, if not most, Americans. The people that once had a goal of "a chicken in every pot" seem now to want a steak on every grill, a car for every member of the family, a home and a cottage on the lake, and on and on. Any honest observer would be hard put to deny that ours is among the most materialistic cultures the world has ever known. Many appear to have more faith in their business, their trade-union, their stocks and bonds, their property, or even the "American way" than they do in Christ. Even the poor are not free of this malady of materialism; for those who have it want to keep it, and those who don't, want to get it.

We could learn a great deal from the Colonial Quaker Christian, John Woolman. Woolman was a successful merchant, but he operated his business each year only long enough to accumulate enough money to care for his family's needs for the year. The rest of the time he gave to the service of the Lord, traveling about the young nation at his own expense to share the good news.[30]

Is it really necessary for most businesses to operate seven days a week? Could we give more time and money beyond our needs to the Lord's work?

RAYMOND H. BAILEY

Matthew 6:30 Dependence

During the football season, I met with the team of one of our local high schools for a pregame prayer. Standing amid the coaches and players, I prayed; then we repeated the Lord's Prayer together. As I left the group to find my seat in the stands, I shook hands with the coach and said, "Good luck, Coach!"

Then as I made my way to my seat, the thought struck me: this is the height of incongruity. I had prayed for God's help, strength, and protective care. But I had also wished the coach good luck. Luck and prayer don't go together.

Luck, by definition, is that which happens to one by fate, chance, or fortune. It comes without regard to preparation or work. Luck is that good fortune that just happens to fall one's way.

Prayer, by definition, is communing with God. It is the attempt to find God's will, to know God's heart, to receive from God strength and courage and power for the task at hand.

The person who depends on God in prayer does not need to depend on luck. If people are rightly related to God, they receive guidance from the Holy Spirit, not from what just happens to them.

If we are responsive to God's will, we do not need the fickle finger of fate to point us to directions for our lives.

If we live under the protective power of God, it is not luck that delivers us from close places. Of course, we should never presume upon God's grace or God's protective care. But luck has little to do with whether Christians survive.

With an understanding of the providence of God, Christians interpret their lives from the understanding of God's guidance. Those things that caused us to turn corners and to take decisive turns or to make momentous decisions are not prompted by luck but by God. These turns are easier to discern after the fact than before. But looking at life through the eyes of faith, we know God has a place in our lives.

As Christians do not need fortune-tellers to know the future or a zodiac table to know what to do on a day, neither do they need luck to live. We live by dependence upon God, not by luck.

JAMES E. CARTER

———◄━●━►———

Matthew 6:31 Materialism

Our concern for our physical well-being may link humanity to monkeys more strongly than any theory of evolution. A story out of World War II tells about how natives trapped monkeys on their island. The natives took earthen jars, with long narrow necks, and secured them to the trees that were the habitat of the monkeys. They partially filled these jars with grain. At night the monkeys came down from the trees and reached into the jars to get the grain; but when they tried to take their hands out of the jars, they found it impossible because they had fists full of grain. All the monkeys needed to do was to turn loose of the grain, but they refused to do so. They lost their freedom rather than turn loose of the grain.[31] Matthew 6:31 helps us keep material possessions in the proper perspective.

BILL BRUSTER

———◄━●━►———

Matthew 6:33 Priority

A man bought a picture and asked Whistler to assist him in hanging it in the right place. When Whistler walked into the room, the man held up the picture in one place and then in another. Finally, Whistler said, "You are going about this all wrong. What you need to do is to move all the furniture out, hang the picture where you want it, and then arrange all the furniture in relationship to the picture."

We often treat God as a nice addition to the furniture of our lives. What we really need to do is to remove all the furniture, put God in the central place, and then arrange all of the furniture of our lives in relationship to him.

God demands the place of priority in our lives. This was what Jesus meant when he said, "But seek first His kingdom and His righteousness; and all these things shall be added to you" (Matt. 6:33, NASB).

BRIAN L. HARBOUR

Matthew 7:1-5 Judging

Father Angelo in Steinbeck's novel, *To A God Unknown,* heard the rain coming at the end of a long drought. He knew what would take place the next night. He resolved to stop the town people when they began an orgy in the street to celebrate the life-saving rains, a custom long followed in that community. He stepped to his doorway with a phosphorus-coated cross that was visible in the night. But as he started out, he thought about how long the people had waited for the rain and how much they were enjoying themselves. He rationalized that he would not be able to see them in the dark, so he decided to preach against them on Sunday and give everyone penance. With that he returned inside the church, seemingly condoning the people in their sin.

On the surface we might be repelled by a religious leader who backs away from sounding God's claims to such obvious sinners. A closer look can reveal an attitude among church members that duplicates the priest's action time and time again. When someone's behavior is called into question, we have both heard and said, "Judge not, that you be not judged" (RSV) or "Of course, I would not judge because we are not supposed to judge." The implication is that it is not right to judge the behavior or words of another person because of the view that Jesus taught we are not supposed to judge another.

The fact is, Jesus did teach that we are to judge! The point Jesus was making is that we are to use the same standards to judge ourselves that we use to judge others. Judging is never one way. And we are to deal mercifully with others in our judging of them. We are not given the option not to judge—we are to judge! The problem is, most of us are poor judges, and we fail to judge ourselves first. If we are faithful to the Bible, we must teach and practice judging.

ROBERT W. BAILEY

Matthew 7:1-5 Jealousy

There is a fable that the devil was once crossing the Libyan Desert

when he met a group of small friends who were tempting an old hermit. They tempted him with the allurements of a beautiful woman. They failed. They sought to sour his mind with doubts and fears. They failed. They tried to force him into self-pity by telling of his austerities. But it was all to no avail. The holy man seemed impeccable.

Then the devil stepped forward. Addressing the imps, he said, "Your methods are too crude. Permit me for a moment. This is what I recommend." Going up to the hermit, he said, "Have you heard the news? Your brother has been made Bishop of Alexandria." The fable relates how immediately a scowl of malignant jealousy clouded the serene face of the holy man.

HAROLD T. BRYSON

Matthew 7:7 Prayer

Where do we go for help to meet our needs? In one of "The Family Circus" cartoons by Bill Keane, the older brother leans on a crushed football and says, "I need a new football. I don't know if I should send up a prayer, write a letter to Santa Claus, or call Grandma."[32]

Our Father knows our needs, and Jesus encourages us to "Ask, and it shall be given you."

BILL D. WHITTAKER

Matthew 7:7-11 Prayer

Several years ago a young Danish student on a tour of Washington, DC, visited the Washington Monument. He lingered at the top after his group took the elevator to the exit. At 5:15 he noticed a sign that indicated the doors closed and the elevator stopped running at 5:00 o'clock. He ran down the stairs and at the bottom beat upon the doors and screamed for help. Finally, he discovered a phone, pried the cover off, and dialed for help. Within minutes he was released by park officials. He had undergone three hours of agony before he discovered that help was within reach all the time.

Prayer is not magic; neither will it instantaneously deliver us from all our woes. Yet, God is as near as a cry for help, and he will either deliver us or give us the grace to deal with our difficulty. But in our panic, we tend to scurry fitfully from inadequate solution to illusion. For the people of God, help of some kind is always within reach.

W. WAYNE PRICE

Matthew 7:13-14 The Narrow Way

Myron Augsburger was asked one day if he had seen a painting which depicted the broad and narrow way which Jesus portrayed. When he said yes, he was asked to describe it. He recounted a painting with the broad road leading downhill filled with people on it. The narrow road was over at the edge of the picture winding up a mountain to the golden city in the distance.

"But that is wrong," his friend interrupted. "The narrow road is right in the middle of the broad road—just heading the other way." Dr. Augsburger had to agree. With their backs toward God, many travel the broad road away from God. Those seeking to follow God find that the narrow road often runs head-on into the stream of humanity going the wrong way![33] To walk in the way of Jesus is demanding, but Christians take that path unashamedly because they know it is the way which leads to life in all its fullness.

WILLIAM P. TUCK

Matthew 7:14 Life

Life's experiences support the injunctions of the Bible. For instance, an alcoholic rehabilitation center in Paterson, New Jersey, is located at the intersection of Straight and Narrow Streets.[34]

Like the Bible says, "Strait is the gate, and narrow is the way, which leadeth unto life, and few there be that find it."

JACK GULLEDGE

Matthew 7:21 Action

A salesman wrote a letter to his boss which said:
"Dear Bos:
I seen this outfit which they ain't never bot a dim's wurth of nothin
from us and I sole them a cuple hundred thowsand dollaws wurth of
guds. I'm gwine to Chawgo."

Two days later, a second letter arrived at the home office:
"Dear Bos:
I cum hear and I sole them half a milyon."

Both letters were posted on the bulletin board with a note
appended by the company president. "We been spendin to much time
hear tryin to spel instead of tryin to sel. Let's watch these letters from
Gooch who is on the rode doin a grate job for us, and you go out and do
like he dun!"

Performance, and not promises, is what counts in life. So it is in
the Christian life. Jesus is not interested in profession as much as he is
interested in performance. Not talking about our faith but demonstrat-
ing it is the singular challenge that comes to us all. Jesus said it like
this: "Not every one who says to Me, 'Lord, Lord,' will enter the
kingdom of heaven; but he who does the will of My Father who is in
heaven" (Matt. 7:21, NASB).

BRIAN L. HARBOUR

Matthew 7:24-27 Foundation

The federal government erected a new multimillion dollar court-
house in Philadelphia. The building was almost completed when
inspectors noticed cracks in the brick facing the inner walls. Tests
determined the building was beginning to tilt on its foundation. The
cause was a decision to shorten the foundation pillars. An extra ten
million dollars was spent repairing the damage and providing adequate
support for the building.

The foundation is crucial in construction and in life. The wise

build "upon a rock," which will provide stability in the storm. The wise person will build on the sayings of Jesus and be obedient to his word.

BILL D. WHITTAKER

Matthew 7:24-29 Foundations

Living in a city that claims to have the whitest sand in the world, I am always happy to get away to the beach for a few hours with my family. One of our first excursions to the beach provided an opportunity to test our skill at sand-castle construction. As my wife soaked up some sun, I sat down with our children to build a sand castle. I had completed a wall on three sides. The tower in the center was about eight inches high. It was beginning to take shape. But then a wave came rushing in and swept my sand castle away.

Many people's lives are like that. Every wave sweeps away what they have built because they have built on a faulty foundation. Jesus used this analogy of building on the sand to describe the foolishness of people.

He offered a better way. Wise people are the ones who hear God's words and act on them. Knowledge of and obedience to the Word of God is the only foundation for life that will really last.

BRIAN L. HARBOUR

Matthew 8:3 Love

Imagine having a child and not being able to touch him. A little boy in Texas has a rare disease which has rendered his body incapable of resisting any germ, virus, or infection. Since birth he has lived in a closed environment. His parents have touched him with only rubber gloves. He ventures outside his closed environment in a special life-support suit developed through space research.

Many people suffer as untouchables in the realm of relationships.

Jesus put love into action by touching the untouchables—the leper, the Samaritan, the religiously unclean.

BILL D. WHITTAKER

Matthew 8:10 Faith

As a preacher spoke about faith, he lifted his left hand in front of him with his fingers spread apart. He said, "Let me tell you what faith is so that you will remember it."

He spelled out the word *faith* and, as he did it, he touched each finger of his left hand.

He said, "Now, everyone spell *faith* with me."

They all joined him: "F-A-I-T-H."

He said, "Repeat it." And they did several times, as he led them. "Now, let each letter stand for a word."

He pointed to his fingers, as he had before and spoke these words: "Forsaking All I Take Him."

He had the congregation repeat with him several times: "F-A-I-T-H, Forsaking All I Take Him."

This is a simple definition, easy to remember and yet it expresses well the meaning of faith.

ELMER L. GRAY

Matthew 8:23-27 Calming the Storm

William Barclay, late preacher, teacher, and writer in Scotland, was best known through his seventeen volume *Daily Study Bible*. In another of his writings, he told a very personal story which makes his contribution as a minister all the more significant. He said that many years before, his twenty-one-year-old daughter and the young man she was to marry were drowned in a boating accident. He recalled that God did not calm the storm that caused their deaths but he did calm the storm in Barclay's own life.[35]

At the very least, Matthew's account of the calming of the storm reminds us that God does quiet some threatening storms of wind and rain. Some other storms are allowed to run their course and destroy love and life. They are the storms of accident, ill health, broken relationships, and the power of evil running wild. Sometimes God calms the storms within us, and in the calm that follows he becomes more real than he was before.

W. WAYNE PRICE

Matthew 9:9 Commitment

Fifty-six patriots signed the Declaration of Independence, an act the British Crown considered treason. King George III wanted each man hung and by devious means secured their names. But such parliamentary giants as William Pitt, the Elder; Edmund Burke; and Charles James Fox would not have it. So the king's view was left to the British field forces to carry out. The American War of Independence dragged on for seven grueling years. Before the issue was settled, the British army and Royalist sympathizers heaped abuse, false charges, and economic, as well as personal, misfortune upon many of the signers.

John Hancock, the first of the patriots to sign—and in large letters so none could mistake his intention—was declared an outlaw by the British, and a bounty of fifty pounds was placed on his head. Only the American triumph in Boston saved him. The New York signers—Francis Lewis, William Floyd, Philip Livingston, Lewis Morris—all lost their extensive properties, and Lewis was reduced to a widower through the trauma. John Hart, Richard Stockton, John Witherspoon, and Francis Hopkinson saw their New Jersey properties looted, and the brutality of Richard Stockton's treatment in prison drew General George Washington's protest to British General Howe. Stockton was released, but died penniless soon thereafter.

Others—Dr. Benjamin Rush and George Clymer of Pennsylvania, William Ellery of Rhode Island, Edward Rutledge, Arthur Middleton, and Thomas Heyward, Jr., of South Carolina, Carter Braxton of Virginia, William Hooper of North Carolina, and Lyman

Hall of Georgia—were all impoverished or imprisoned because of their commitment to the American cause.

When they signed the Declaration, they fixed their names to a pledge: "And for the support of this Declaration, with firm reliance on the protection of Divine Providence, we mutually pledge our lives, our fortunes, and our sacred honor." Some of the signers, in making good that pledge, paid prices that can be reckoned only in blood and anguish. All of them ran the risk of so doing.[36]

Perhaps their story helps us understand better the commitment Matthew made when, as recorded in Matthew 9:9, we read, "He arose, and followed" Jesus. Luke added, "He left all" (5:28), a fact Levi may have been too modest to admit. But he did not leave quite all; he took his pen and used it later to write a Gospel!

Each in his own way, Matthew and the signers of the Declaration, made a commitment. We know that by the price they paid. And how else is commitment known?

RALPH L. MURRAY

Matthew 9:9-13 Kindness

In July, 1656, twenty-two-year-old Baruch Spinoza was summoned before the elders of the Amsterdam synagogue on the charge of heresy. Earlier in his life he had definite leanings toward philosophy and had questioned some of the traditional faith of the fathers. He was charged with believing that God might have a body, angels might be hallucinations, the soul was merely life, and the Old Testament said nothing of immortality.

The Jewish officials offered the young scholar five hundred dollars annually if he would maintain external loyalty to the synagogue. He refused. Thus on July 27, 1656, he was excommunicated with a curse. "There shall no man speak to him, no man write to him, no man show him any *kindness,* no man stay under the roof with him, no man come nigh him."[37]

Such religious action is brutally in contrast with Jesus' desire, "I want kindness."

JAMES M. PORCH

Matthew 9:10-13 Hope for Sinners

On one of Dr. Howard Thurman's trips to India, a little boy from a village heard the famous American minister. Later that night, after Dr. and Mrs. Thurman had gone to bed, there was a knock at the door. When they opened the door, they were greeted by a lad whose clothing identified him as an untouchable. The young boy spoke politely in fairly good English and said: "I stood outside the building and listened to your lectures, Sahib Doctor. Tell me, please, can you give some hope to a nobody?"[38]

Jesus Christ reached out to the nobodies of his day and has continued to extend his hand to the needy down through the centuries. "For I came not to call the righteous, but sinners" (Matt. 9:13, RSV). When Jesus quoted Hosea 6:6, "I desire mercy, and not sacrifice," he was rebuking the Pharisees who had reduced religion to the observance of certain traditions and customs. Jesus broke through this religious barrier and showed his concern for the poor, the disadvantaged, and the sinful.

WILLIAM P. TUCK

Matthew 9:12 Need (Freedom)

Francois Prevost was an early nineteenth-century physician known for his obstetrical skill. A simple country doctor, he chose to practice in a remote Louisiana parish where the needs of the poor were great. Dr. Prevost astonished medical authorities by delivering babies safely through Caesarean operations. Alone in a Negro cabin dimly lit by a candle or an oil lamp, assisted only by a slave woman, without anesthesia, without asepsis, without modern instruments to control hemorrhage, he saved seven out of eight lives by an operation which had been condemned in the greatest hospitals in the world. His patients were slaves; his fee was a promise from each slave's owner that if the operation were successful both mother and child would be free.[39]

The religious establishment of Jesus' day condemned an innovative gospel that broke out of meaningless rituals and traditions. Under

great stress and criticism, the Great Physician chose to minister to the poor and needy. He sat down with the publicans and sinners (Matt. 9:12). The Pharisees questioned his practice. Jesus simply answered that he went where the need was the greatest and secured our freedom from sin's bondage.

JACK GULLEDGE

Matthew 9:36-38 Concern

Dr. James Coggins, pastor of Travis Avenue Baptist Church in Fort Worth, Texas, told of a tragedy that occurred one Sunday night as his congregation worshiped. Within the shadow of the church, just four doors away, a young man, twenty-three years of age, took his own life. Dr. Coggins was called to minister to the family. As he went to their home, he discovered that they had no church affiliation. They were four doors away from the church, hurting spiritually, yet were not being influenced by what the church was doing.

The same thing is happening in many churches. Worship services are held every week but people within the shadow of the buildings are untouched by Christ. How can that be? Lack of concern and ineffectiveness in outreach are the only explanations. How we need to hear again the challenge of our Lord, "The harvest is plentiful, but the workers are few. Therefore beseech the Lord of the harvest to send out workers into His harvest" (Matt. 9:37-38, NASB).

BRIAN L. HARBOUR

Matthew 10:1-5 The Mission of the Church

A visitor in a strange city was returning from supper when a sign in a store front window caught his eye. It read "Chinese Laundry." He made a mental note of the location because he had been gone long enough to have need of a good laundry. The next morning he arrived at the store with a bag full of soiled clothes.

He piled the clothes on the counter before a shocked attendant.

"What's that?" the attendant asked.

"My laundry," came the reply. "I've always heard that Chinese laundries do excellent work." The startled clerk quickly informed the visitor that the establishment was not a Chinese laundry. "But what about the sign in the widow?"

"Oh, this is not a laundry, it is a sign shop."

The church sometimes sends out false signals about its purpose. Needy people bring in their dirty laundry only to discover that the cross of forgiveness is only a sign and that the attendants are not equipped to handle soiled lives.

RAYMOND H. BAILEY

Matthew 10:26-31 Fear

Christian reached the Palace Beautiful in *The Pilgrim's Progress*, only to be dismayed that the entrance to the palace was guarded by two lions. Discouraged and fearful, he was ready to turn around and go back. He was ready to admit defeat and conclude that he would have to return where he started. But a companion told him to go forward bravely. Christian finally did advance. And to his amazement he found the lions were chained and could not touch him, in spite of their loud roaring and ferocious looks.

How many times have we been overwhelmed with fear of a problem or situation which actually could not or would not do us any harm if only we would advance instead of sitting down or retreating in fear! There are many fears that easily beset us—the fear of death which blocks our abundant living, the fear of guilt which closes off our forgiveness, the fear of meaninglessness which deflects our purpose. When our sin and fear combine to render us immobile, then our nerve of moral action is severed, and we are like the description of Hamlet as "his own termite, and from a tower has eaten himself down to a heap of sawdust."

At the bottom of our feelings, we must determine whether or not we want to be brave, to have courage, to be set free of our fears. Jesus emphasized that we can trust his father and be free of fear (Matt. 10).

We do have a choice to make because when we refuse to pay the price to allow God to free us from fear, we choose to live in cowardice and self-pity, feeling sorry for ourselves and implying that God is not good enough or big enough to take care of us. God has made his promise and offered his strength, so we can go on past the roaring lions he will shield us from when we trust in him.

ROBERT W. BAILEY

Matthew 10:28 Hell

We were driving just outside of the old, walled city of Jerusalem when the tour guide said over the loudspeaker, "We are now in the valley of Hinnom."

I turned to my wife and said, "You are now right in the middle of hell."

Our English word *hell* translates a word that means the valley of Hinnom. The valley of Hinnom was immediately southeast of the city of Jerusalem. In ancient times, it had been the location of the worship of the heathen god Molech, which included burning babies alive. This practice was abolished by King Josiah, and the place came to be used by the Jewish people as a place for garbage disposal, including the refuse from the city, the bodies of animals, and even the bodies of criminals who had no one to bury them. A fire was kept going continuously for sanitary purposes. The term came to be generally used to present the idea of that which is abominable.

JAMES E. CARTER

Matthew 10:32-33 Confession

The name Margaret Hool appears in our family genealogy from about the middle of the last century. We had little other information, except that she was a native of Canada and had married my great-grandfather in an upstate New York town in 1849. But an on-site investigation of her line in Canada disclosed that her baptismal name

was Marguerite Houlle and that her forebears include prominent French Canadians, reaching back to the early sixteenth century. The investigation also revealed that Marguerite left her family, home, and native land when a girl of eighteen to marry a Protestant émigré to the United States—my great-grandfather.

When we left the church in that Canadian town across the Saint Lawrence from Montreal, my mind was reeling with questions: *What about her faith? her religious commitments? Did she leave all that behind when she joined her new husband in America?* All such questions found an answer in a response one of my father's oldest brothers made to my letter of inquiry. "She was baptized into the Walnut Street Baptist Church in 1908 at the age of seventy-two." Nine children and fifty-four years later she made her confession.

Confession is important. Matthew 10:32-33 often is used to support that truth. Usually we think of confession in terms of its inner meaning to the confessor. But confession has two sides. One is the inner side, what the confession means to the one confessing. The Gospelist used a word in Matthew 10:32-33 which is often translated "confess" or "acknowledge." Literally the word means "to say the same as." Confession or acknowledgment used this way means to say the same thing about Jesus as God has said. And God said, as reported in Matthew 3:17, "This is my beloved Son, in whom I am well pleased."

The outer side of confession is the witness borne to others by that confession. Shakespeare, three weeks before he died, drew up a will which opens like the credo of a confessing Christian: "I commend my soul into the hands of God my Creator, hoping and assuredly believing, through the only merits of Jesus Christ my Saviour, to be made partaker of life everlasting, and my body to the earth whereof it is made."[40] Students of Shakespeare take note, as I take note of my great-grandmother's baptism, that the confession proclaims the believing Christian.

So the inner side of confession shows the confessor in agreement with the biblical teachings on our spiritual need and God's provision in Christ. The outer side of confession settles all questions of family, friends, and acquaintances. Both aspects demonstrate the necessity of confession.

RALPH L. MURRAY

Matthew 11:1-19 Childlikeness

There is a vast difference in being childish and childlike. 2 Kings 5 tells the story of a man who played both roles. His name was Naaman. He was a captain in the Syrian army, but he was a leper. Naaman was told by a Jewish slave girl that there was a prophet in Israel who could heal him. He set out for Israel and found the house of Elisha, the prophet. Elisha sent a message to Naaman, "Go and wash in Jordan seven times."

Naaman refused saying, "Are not Abana and Pharpar, rivers of Damascus, better than all the waters of Israel?" Then he began his journey home—acting like a child. Elisha had not done what Naaman had expected. He was too childish to submit to the prophet's command.

Just then, Naaman's servant gave him some sound advice. He encouraged Naaman to do what Elisha had asked. Finally Naaman threw aside his childish pride and bathed in the Jordan. When he did, his flesh was made whole again.

Many of us are like Naaman. We are more often childish than childlike. Were our Lord to speak, would he be forced to say, "You are like children playing in the market place." There is a world of difference in being childish and being childlike. Jesus condemned one and commended the other.

JAMES A. YOUNG

Matthew 11:2 Doubt

The questions our age has about the finality of Christ are surely nourished by the doubts expressed by our novelists and playwrights. Will Durant says it was at Stanford that John Steinbeck "began to shed that Christian faith, lonely and terrible, whose loss he never ceased to mourn," while for William Faulkner, "God is chiefly an expletive," and all of Upton Sinclair's works "constitute a silent monument to a nobleman without pedigree and a Christian without creed." Durant says of Eugene O'Neill: "He inherited the Catholic Faith, lost it, and

longed for it: he disliked Protestantism, and despised Puritans, to the end." At O'Neill's death in 1953, his wife records: "He wished nobody to be at his funeral but me and his nurse. He wished no religious representative of any kind."[41]

J. DANIEL DAY

Matthew 11:28 Acceptance

Now there is a new thrill for those who frequent the nightclubs. You can be "selectrocuted." It is a part of a new computerized matchmaking game invented by Geoffrey Aydelette. After a night at the club, each of the players are ranked on their sex appeal. Votes are registered in the computer. If a person gets few or no votes, the computer declares him or her "selectrocuted." That is the way the world evaluates people. If you have something to offer, by the world's standards, you are accepted. When you have nothing to offer, you are "selectrocuted" or just simply discarded.[42]

How different that is from the way Jesus relates to us. The world says to worthless, broken humanity, "Go away." But Jesus says, "Come to Me, all who are weary and heavy-laden, and I will give you rest" (Matt. 11:28, NASB). The world says, "I don't want you unless you have something to offer." Jesus says, "I do want you, because I have something to offer you."

BRIAN L. HARBOUR

Matthew 11:28-29 Invitation

"Take my yoke" was a phrase used by a Jewish rabbi to invite a person to become his pupil, according to Herschel H. Hobbs.[43]

A yoke was a wooden bar fashioned to fit across the necks of two oxen so they could pull a load together. The yoke Jesus offered would be well fitted or "easy" because Jesus would be under the yoke with his disciple.

This invitation of Jesus might be compared to the advice and offer

of a physician to a patient. A doctor urges a patient to turn from such actions and habits that keep his physical system from functioning well and that actually damage him. He prescribes a discipline of treatment and behavior that counteracts an illness and that encourages good health. Furthermore, he promises that cooperation will result in an improvement of one's condition.

Jesus' invitation to those "who labour and are heavy laden" was specifically to persons who sought diligently to establish their own righteousness by obeying the Law. Such persons would be like those who try to doctor themselves when they need a specialist. Jesus promised to give them "rest" which is victory over worry, tension, and meaninglessness. Also he promised to let them participate with him in the great things he was doing.

ELMER L. GRAY

————————

Matthew 11:28-30 Burdens

Several years ago a television movie was aired about a young man in a ghetto who was struggling to find himself and his place in life. He made several drastic mistakes, including attempting to take his own life as a final escape from his hellish existence. After recovering from that attempt, his mother was anxious that he would repeat that destructive act, perhaps being successful the second time. The son stood on the rooftop of their apartment building and declared to her that he was either going to live or die—he could no longer just survive!

There seem to be many people like that young man all over our world today—people who are tired of just existing, of dragging themselves through life, of repeating the same drab things over and over. And not all these people live in the typical ghetto. Our modern society has created ghettos beyond the minority slums. We have emotional ghettos, relational ghettos, intellectual ghettos, cultural ghettos, and spiritual ghettos. We are burdened down with many forces and stresses that will destroy us unless we learn how to deal with our burdens.

We need to learn how to share our burdens with another. We most especially need to learn how to share our burdens with Christ, who

invites us to cast our burdens on him and take up his yoke. As a
yokefellow of Jesus Christ, we have One with whom to share our
burdens, and thus his yoke is easy and his burden is light. We can try it
all alone and wind up with frustrated survival, or we can try life in
relation to Jesus Christ and know relief for our burdens.

ROBERT W. BAILEY

Matthew 11:28-30 Discipline

Anne Sullivan is reported to have decided very early in her
relationship with Helen Keller that discipline was the key to success.
She said that she saw that she could not teach her language or anything
else unless Helen learned to obey her. Later, Ann Sullivan expanded her
observation about Helen Keller to a general principle of learning. She
became convinced that obedience is the gateway through which
knowledge, and love as well, enters the mind of a child.[44]

The yoke seemed to be a symbol of discipline, obedience, and
commitment of disciples to their master. Like Helen Keller to Anne
Sullivan, Jesus' disciples came to obedience, discipline, and love over a
long period of time and by a most painful process. Their lives were
changed.

W. WAYNE PRICE

Matthew 12:9-14 Struggle

One of my favorite stories in the Gospels is the healing of the man
with the withered hand. Matthew's version is found in 12:9-14 and
includes Jesus' question about the relative values of a sheep and a man.
Otherwise, it is very close to Mark 3:1-6. In both versions of the story,
the epicenter of the miracle comes—to my mind at least—imme-
diately after Jesus says to the man, "Stretch out your hand" (Matt.
12:13, RSV).

Imagine the struggle that followed on the heels of that command!
Here was a man whose hand had been lifeless, tradition says, for thirty-

eight years. And now, Jesus commands him to do what he has wanted all these long, tedious years but could not. That the man did manage to outstretch his withered hand and be healed is almost anticlimactic. The extension and restoration of the hand may be the most significant part of the story, but what of the mind-searing struggle to use atrophied muscles and nerves that had been useless so long? The miracle was born in that struggle.

Sometimes we tire of struggle. We want comfort, ease, and the absence of strife. But do we? Really? Legend tells of a man who wanted no struggle. To his delight, he was taken to such a place at his death. His every wish was granted; he had no challenge in his life at all. But he soon was bored and asked those in charge for just a little challenge. Not much, just enough to keep the monotony broken. But instead he continued an existence in which everything he wished was granted. Immediately. Things went from bad to worse until finally the man cried out, "I can't stand this comfort! I want to feel the thrill of struggle again. I want to go to hell!"

The attendant looked surprised and asked, "Sir, where do you think you are?"[45]

Struggle can be the spice of life. Relish it; challenge it; overcome it. "Stretch forth your hand!"

RALPH L. MURRAY

———◆◆◆———

Matthew 12:22-32 Choices

Robert Louis Stevenson has written some of the best short stories. One of his most imaginative stories is *Dr. Jekyll and Mr. Hyde*. Dr. Henry Jekyll was a prominent and brilliant physician, and he was constantly experimenting in his laboratory. Once he found an insidious chemical formula which would change him alternately into two persons. One "self" was his whole, good, and pure person. The other "self" was the dark side of his nature embodied as evil. The evil personage was named Mr. Edward Hyde. Hyde became an inhuman monster when he was set free from the restraints of Jekyll's conscience.

The story reached a tragic climax when Dr. Jekyll could no longer control his transformation into Hyde and back again into Jekyll. Dr.

Jekyll had lost control of his original and better self. He was becoming slowly incorporated with the sinister Hyde.

The unpardonable sin occurs when we depart from the self God intends us to be. Instead of opening our lives to God, we open them to evil. Like the experience of Dr. Jekyll, we could find ourselves being mastered completely by the sinister forces of evil.

HAROLD T. BRYSON

Matthew 12:25-26 Wholeness

Abraham Lincoln noted, "A nation divided against itself cannot stand." Strength and usefulness grow out of wholeness, not division.

Lincoln also told of a small, but beautiful, steam engine kept in a woodyard near Bloomington, Illinois. Its engineer kept the locomotive in mint condition and took pride in its huge whistle, audible up and down the Sangamon Valley.

But the engine had one flaw. Its boiler was too small. As a result, the engineer was faced with an ongoing dilemma. If he blew the whistle, there wasn't enough steam left to power the locomotive at the same time. It's too bad the original design built in a division—either noise or performance. Wholeness, the ability to announce itself and to work simultaneously, would have made the little engine effective.

ROBERT D. DALE

Matthew 12:36 Idle Speech

Introducing Thomas Alva Edison at a dinner, the toastmaster mentioned his many inventions, dwelling at length on the talking machine. The aged inventor then rose to his feet, smiled, and said gently: "I thank the gentleman for his kind remarks, but I must insist upon a correction. God invented the talking machine. I only invented the first one that can be shut off."[46]

God did give us the gift of speech but attached responsibility for

its use. In Matthew 12:36, we are warned that "every idle word that men shall speak, they shall give account thereof in the day of judgment."

<div align="right">JACK GULLEDGE</div>

Matthew 12:38-42 Miracles

Humans thirst for miracles. We want to be convinced.

Senator Sam Ervin tells a humorous story about miracles. After North Carolina outlawed homemade whiskey in 1908, Granville County moonshiners agreed to make only enough liquor for home use. The county sheriff heard two brothers were shipping their "surplus" to Durham and Henderson by train in barrels marked "Molasses." The sheriff staked out the train depot and caught the brothers with a wagon load of barrels.

"What you got in those barrels, boys?" the sheriff asked.

"Just water, Sheriff."

The lawman thought a moment and said, "I'm a mite thirsty. Mind if I have a sip?"

The sheriff took a swallow and recognized 150 proof corn whiskey. Wordlessly, the sheriff handed the dipper to one of the brothers and waited for his response.

Without pausing, the moonshiner drank a mouthful, threw back his head in mock surprise, and exclaimed, "Wow! Jesus done done it again!"

<div align="right">ROBERT D. DALE</div>

Matthew 13:13 Communication

Communicating effectively, whether by parables or other devices, has always been a problem. Kierkegaard, a master of parable, described it well in his parable of the man who saw in a shop window a sign,

"PANTS PRESSED HERE." He went in and began removing his pants. The alarmed shopkeeper stopped him, explaining that he did not press pants. He painted signs.

J. DANIEL DAY

Matthew 13:15 Conversion

One of our church ladies who is a first-grade schoolteacher told me of an interesting incident that occurred as the school year got under way.

The mother of a first-grade girl visited her before school began. The mother made the visit to tell the teacher that the girl had open-heart surgery during the summer. Therefore, she would both desire and deserve a little extra care. The mother went on to say that the girl had accepted Christ as Savior and had been baptized shortly before her surgery. Of course, she was apprehensive about the surgery but had managed to keep it to herself.

The day before the surgery the surgeon again met with the child and explained exactly what he would do.

The girl seemed a little upset, and the doctor inquired about what was bothering her. She said, "I just accepted Christ as my Savior, and Jesus now lives in my heart. When you cut open my heart, you won't let Jesus out, will you?"

To which the physician replied, "Sweetheart, if Jesus Christ is in your heart, there is no way that anyone can get him out of your heart."

And there isn't. The theological term we use for it is the eternal security of the believer. The catch phrase that is used for it which, like all catch phrases, does not adequately express it is "once saved, always saved."

The salvation experience is such that, whenever one accepts Christ as personal Savior and is born into the kingdom of God, he can't be unborn. Once Jesus has come into your heart, someone else can't get him out of it.

How do you express the salvation experience? It is so comprehensive, all inclusive, and life changing that it is difficult to express. The

way the children express it by saying that Jesus comes to live in your heart isn't bad.

How do you express the eternal nature of salvation? That, too, gets difficult to put into words. To say that once Jesus has come to live in your heart, no one can let him out isn't bad. After all, your heart does become his home, and he lives within you throughout all of life and into eternity.

JAMES E. CARTER

Matthew 13:30 Growth

One of the joys of a new house is a new yard. By some conspiratorial means, building contractors knock down whatever trees and scrape off whatever grass may be on a lot.

When you move in a new house the yard looks like the great American desert with no sign of a tree, a shrub, or a blade of grass.

In order to stay in the good graces of the neighbors, to say nothing of covering the ground to keep it from washing away with the rain or blowing away with the wind, you feel duty bound to work in the yard. That means planting grass, planting shrubs, and ultimately putting out some trees. And since the good Lord sees fit not to send rain regularly in Texas, it means watering often.

When the grass in our yard was first planted and we began to water, there were no extra weeds in our yard. But once we began to put the water to it, all sorts of strange and unusual things began to appear. In fact, the unplanned vegetation seems to grow better than the planned material. I think that every weed to which Texas pastures are heir has come up in our yard: crab grass, nut grass, bull nettle, thistles, and stickers have all appeared in abundance.

What happened, of course, is that the seeds were present in the soil already. It took the water to bring them out.

And I think about the things that might be in our lives. There can be ugly, useless, and self-defeating things in our lives. Ugliness, bad temper, rotten disposition, improper attitude, selfishness, ingratitude, or a critical and negative spirit may be a part of a life. These things result in no good harvest. But if they are the things that are present in

the life, they will occur when the conditions for cultivation are met. Like the weeds and the thistles, they will grow if they are given the encouragement to grow and are not rooted out.

In the same way good qualities, such as love, kindness, gentleness, thoughtfulness, selflessness, dedication, and faith can grow too. But these things never just naturally show up in a life. They, too, must be present in seed form and then be given the conditions for cultivation.

As in Jesus' parable, the weeds and the wheat can grow along together until the time for harvest. Then the tale is told. What you grow in your life will be determined by what seeds you plant and how you water them with God's grace and Christian cultivation.

JAMES E. CARTER

Matthew 13:44 Sheer Joy

William Barclay, the distinguished New Testament scholar of Glasgow University, recounted an experience which he had one day at an after-lunch meeting at Trinity College in Glasgow. One of the guest speakers was a famous clown, Rikki Fulton. Barclay said that he had never seen a man who was more thrilled with his job. "I don't want to make people laugh," the comedian said. "I want to make them *shriek*!" He spoke of the joy he received from getting a letter from someone whose sadness had experienced again God's good gift of laughter.

Barclay observed that one could not help feeling the difference this man felt for his job and the dull, dreary mood of many others for theirs. The man's message, Barclay believed, "was a moving appeal for the rediscovery of joy in the church."[47]

The New English Bible translates this passage about the man who found the buried treasure with the words, "for sheer joy." "For sheer joy" he "went and sold everything he had, and bought that field." One who has experienced the power of the transforming Christ will joyously give up everything for him because he knows that it is worth it. Jesus stated that his joy should be in his people and that their joy should be full (John 15:11). Paul echoed this refrain, "Rejoice . . . and again I say, Rejoice" (Phil. 4:4). Christians should not be the hollowed-eyed and

dispirited ones. We who have received the good news of God in Christ walk in the joy of his presence.

WILLIAM P. TUCK

Matthew 13:44 Kingdom

Mair Baulch hoped to raise some money for the Manchester, England, Rose Hill boy's home where she worked. A large painting gathering dust on the wall seemed to be one way. It had been regarded as a nuisance. Closer examination by art experts revealed the iceberg scene was a lost painting by Frederic Edwin Church, leading nineteenth-century American painter.

The painting was eventually sold at auction in three minutes and forty-five seconds for $2.5 million. Rose Hill boys now benefit from a trust fund established with a part of the proceeds.[48]

Jesus likened the kingdom of heaven to hidden treasure—so valuable people would sell all they own in order to possess it. Sometimes the treasure remains hidden within the kingdom—the value unrecognized, unexamined, unshared with a spiritually impoverished world.

BILL D. WHITTAKER

Matthew 13:52 "Something Old—Something New"

There is an old story about the country church that met for their annual July business meeting. As happened every year, one faction gathered on one side of the church and another group gathered on the other. The moderator called the church to order, read the minutes of the last meeting, and finally called for new business. One man jumped up and said: "What this church needs is a chandelier. I make a motion that we buy one." The motion was promptly seconded from someone on his side of the house.

Then another man got up from the other side of the room. He began: "We don't need a chandelier. I ain't never seen one, I ain't never

rode one, and I ain't never et one. What this church really needs is a new light fixture!"

The story is funny because both men were seeking the same thing. And yet, neither understood the other. Chandelier or light fixture—it really doesn't matter. Everybody needs help and guidance as we move on down the road. And the question is this: Where do we find the light we need?

As we read between the lines of the gospel of Matthew, we see that a struggle was going on in the life of the early church. There were some who tried to stifle life; they were afraid of anything new and untried. They were cautious and conservative—afraid the whole thing would go down the drain unless they were extremely careful. But there was another faction—more freethinking. They just knew if they didn't plough new ground and forget about the past, the gospel would never move beyond Judaism. They were more open in their thinking. They were more tolerant of differences and new opinions. They wanted a new light fixture.

The early church, one and all, liberals and conservatives, wanted light, but not all of them found it. Some, in their rigidity, were bypassed by the world, and those churches soon died. But others, following the fads of the day, were completely immersed in the culture around them. They, too, faded from the scene because they could not be distinguished from the world around them.

Matthew had a word for both camps. "Jesus said to them, Therefore every scribe who has been trained for the kingdom of heaven is like a householder who brings out of his treasure what is new and what is old" (RSV).

ROGER LOVETTE

Matthew 13:53-58 Unbelief

On a plaque in the National Historical Site marking Abraham Lincoln's birthplace near Hodgenville, Kentucky, is recorded this scrap of conversation:

"Any news down t' the village, Ezry?"

"Well, Squire McLains's gone t'Washington t'see Madison swore in, an ol' Spellman tells me this Bonaparte fella has captured most o'Spain. What's new out here, neighbor?"

"Nuthin' a'tall, nuthin' a'tall, 'cept fer a new baby born t'Tom Lincoln's. Nothin' ever happens out here."[49]

When I read that plaque's inscription, my mind echoed a question found in Matthew 13:55: "Is this not the carpenter's son?" The natives of Nazareth asked their question about Jesus, just as the natives of Kentucky passed their judgment on the baby "born down t'Tom Lincoln's."

"Familiarity breeds contempt" we sometimes say. That old maxim could be altered to read, "Familiarity breeds *unbelief*." Often our familiarity with our own milieu blinds us to the possibilities of God's coming into a familiar situation in a surprising way.

Perhaps the saddest aspect of unbelief through familiarity falls three verses later in Matthew 13:58, "And he did not do many mighty works there, because of their unbelief." (RSV).

RALPH L. MURRAY

Matthew 13:58 Persistence

On one occasion when Jesus visited his hometown, he met a great deal of skepticism. They said that he was merely a carpenter's son and that they knew his brothers and sisters, who were just common people.

As a result, "he did not many mighty works there because of their unbelief."

But this didn't discourage our Lord. He kept right on healing, teaching, and witnessing. Anyone can face disappointment; it takes persistence to be a real winner.

Thomas A. Edison (1847-1931) changed the lives of millions with such inventions as the electric light and the phonograph. In 60 years, he patented over 1,100 inventions. He defined genius as 1 percent inspiration and 99 percent perspiration. When he failed to produce results after about 10,000 experiments with a storage battery,

a friend tried to console him. "Why, I have not failed, I've just found 10,000 ways that won't work," he replied.[50]

ROBERT J. HASTINGS

Matthew 14:1-12 Hope Beyond Death

Dietrich Bonhoeffer was a German theologian and preacher who was imprisoned during World War II. One of the classical Christian writings was Bonhoeffer's *Letters and Papers from Prison.* On April 8, 1945, Bonhoeffer conducted a service for his fellow prisoners. Just as the service ended, the German guards came to take him for execution. As he left with the guards, he said to a British officer: "This is not the end but for me the beginning of life." This was John's attitude in the face of death.

HAROLD T. BRYSON

Matthew 14:13-21 God's Feast

A poor, European family was migrating to the United States. The night before they were to embark on the ship that would bring them to their new home, friends in their little village threw a party for them. The food was homemade bread, cheese, and wine. When the party was over, the leftovers were given to the guests of honor to assist them in their long journey. For days at sea they ate nothing but cheese and bread. Sick of stale bread and moldy cheese, the son came to his father and pleaded for something different to eat. His dad took a little of their limited funds and allowed the son to go in search for food. When the boy did not return after a long time, the father went looking for him. He found him in a great dining hall eating at a table covered with fine foods of all kind.

The father was stunned, for he knew the small amount given to the young man could not have purchased such a meal. He began to reprimand the child for bringing shame to the family by eating food for which they could not pay. "But father," the boy broke in, "you don't

understand, all of this was included in the price of passage, and we could have been eating it every day." Many Christians eat stale spiritual bread and moldy cheese. As members of God's family, they are entitled to feast at the banquet table of God.

RAYMOND H. BAILEY

Matthew 15:29-39 Worth Transformed

The worth of a product isn't the simple sum of the value of its raw materials. For example, the price of a canvas and some paint is almost incidental to the worth of a Rembrandt masterpiece.

An ordinary piece of steel costing about $5.50 increases its value as it's shaped into different products. When steel is forged into horseshoes, it's then worth $10.50. As needles, it's worth $4,285. As balance wheels for watches, its value rises to $250,000.

Jesus fed four thousand men (and their families) with only seven loaves and a few small fish as his raw materials. When Christ transforms something, its worth increases dramatically.

ROBERT D. DALE

Matthew 16:15-19 The Church

A little boy tiptoed into his sister's room and began to shake her while she was sleeping. As she slowly woke from her sleep, she looked up at him and exclaimed: "Why did you wake me up? You made me lose my place in my dream."

Sometimes as we look at the church, there is an awareness that many have lost their sense of their rightful place in the vision which Jesus had for his church. The dream has been lost when all one sees of the church is an institution in its "last days," with "the frozen people of God" in "comfortable pews" and "the empty pulpit" before them. This cannot be the church which Jesus envisioned that "the gates of hell could not prevail against it."

John A. Broadus dreamed of a seminary in the South to train men

for the ministry. In 1865, amid the rubble left by war, the dream of the seminary seemed to be dim. But Broadus said to his three colleagues on the faculty, "Let us agree that the Seminary may die, but that we will die first." With a dream like that, no wonder The Southern Baptist Theological Seminary in Louisville survived and flourished.

The early disciples caught the glow from the fiery hammer which Jesus used to fashion his church. His sacrificial death laid the foundations on which Jesus built his church. Through the centuries and around the world, his church has continued to grow on the sacrifices of those who have sensed the Master's dream and followed his way of self-giving love.

WILLIAM P. TUCK

* * *

Matthew 16:18 Church

Karl Marx once said that religion was the "opiate of the people." Because of that conviction, Communism has been trying to destroy the church in every country controlled by Communism. They have been trying without success in Poland. In a survey conducted before the Eleventh Plenary Session of Poland's Communist Party, the Central Committee asked people about their confidence in various Polish institutions. When the public opinion survey was published in the weekly newspaper, *Kultura,* it was discovered that the church was the best loved institution in Poland. The Communist Party came in fourteenth, right behind the police. Neither the gates of hell nor the Communist Party can destroy the church.[51]

BILL BRUSTER

* * *

Matthew 16:18 Church

One time I was traveling through a small Arkansas town. As I was leaving, I passed a church building on the edge of the town. The building needed painting. The roof sagged. The yard was unkempt. The windows were dirty. But just in front of the building was a sign

that proclaimed the following message in large, nonprofessionally painted letters: "WELCOME TO THE POWERHOUSE." The name of the church followed.

As I read the sign and saw the building I thought, "What an incredible claim! How could anyone claim this as a powerhouse?"

But farther down the road the thought hit me once more—the whole claim of the Christian faith is an incredible claim. We are claiming exactly what the sign proclaims. Any church can be a powerhouse for God. Any Christian can be the instrument of God's power.

The whole secret of Christianity is that God's Holy Spirit can work in ordinary people and from this get extraordinary results. The Christian must be a person whose life's power comes from God and not from himself.

Yes, it is an incredible claim. But it is the claim that any Christian and any church can make. When the Holy Spirit is present, any church can be a powerhouse.

JAMES E. CARTER

Matthew 16:18 Victory

In 1661, the state gained control of the church in Scotland and abolished the ordination of most of the clergy and set up its own leaders. As a result, a large number of Christians signed a covenant to resist unto blood the inroads of the government. From May 27, 1661, when the Marque of Argyll was beheaded, to February 17, 1688, when James Renech suffered, about eighteen thousand Covenanters met death.

I visited the Covenanter's Church in Edinburgh. The prison in the church yard where many of the Covenanters were held stands today as mute testimony to their faith and courage. In the haymarket square near the church, over one thousand Covenanters share a common ground. A beautiful monument has been erected over the spot in their honor. At the base of the monument is a large, open Bible with the words of Revelation 2:8-10 engraved on the pages.

Should you visit Scotland today you will see church buildings

turned into bingo halls, warehouses, and places of business. According to the best estimates available, about one of ten persons in Scotland today attend church services. This is quite a contrast to the Covenanters who bared their necks to the sword rather than compromise their faith.

The church in many parts of the world is almost a contradiction of Jesus' words, "I will build my church; and the gates of hell shall not prevail against it." If the church could once again capture the vision of Christ's promise of power and move out into society, it could be victorious.

JAMES A. YOUNG

Matthew 16:23 Words

One of the subtlest temptations to befall humankind is the thoughtless or devious use of words. In George Bernard Shaw's play *Back to Methusaleh,* Adam and Eve talk to the serpent:

ADAM: "Make me a beautiful word for doing a thing tomorrow; for that surely is a blessed and great invention."
SERPENT: "Procrastination."
EVE: "That is a sweet word. I wish I had a serpent's tongue."[52]

The devil is good with words. And if we're not careful, he will speak his words through our mouths. No doubt Peter's brave speech in Matthew 16:23, given on the heels of Jesus' disclosure of his coming passion in Jerusalem, was meant to reassure Jesus. But it did not; in fact, Peter's speech drew from Jesus one of the sternest rebukes found in the Gospels. Why?

Because Peter's words were thoughtless. They were spoken in an unseemly absence of reflection; they were words which rejected reality.

We must watch our words. Even spoken with the best of intentions, they may be the devil's words. And nothing more.

RALPH L. MURRAY

Matthew 16:24 Crucifixion

The president of a stained glass company was at a church to measure for the stained glass windows which were to go over and on each side of the baptistry. While she and the pastor were waiting for the contractor to arrive, they discussed possible designs for the windows.

When they started talking about the two side windows, the president asked, "Would you object if I put a subtle cross in each of those windows?" She was assured that this would be fine.

What do you think about the remark? Do you have a subtle cross? How do you go about getting crucified subtly? When Jesus asked us to take up our cross and follow him, did he mean for us to take up a subtle cross?

There was nothing subtle about the cross on which Christ died. It was set up on the "place of the skull" publicly. Everyone knew that a crucifixion was underway. The place was so cosmopolitan that they had to write the sign in three languages.

Christ doesn't mean for us to take up a subtle cross either. He calls us to boldly declare ourselves to him, to openly accept him, and to actually surrender ourselves to him.

A subtle cross would be a bloodless cross. And Christ would not allow that. A subtle cross would be a cross without commitment. There is no place in the Christian faith for that. A subtle cross would be a silent, secret cross. But faith demands open expression.

Too many of us have tried a subtle cross too long. Let's follow Christ's call and take up the cross of self-surrender and full commitment and follow him—all the way.

JAMES E. CARTER

Matthew 16:24 Selfishness

Gaylord Noyce quoted a friend as saying, "I think I can serve my neighbor in my church work and my civic involvements. I do a lot of that. At work I have to be self-centered, self-seeking."[53] Contrast that attitude with the lives of Dr. Raymond Downing and Dr. Janice

Armstrong. They are a husband and wife team who share a medical practice in Maynardville, Tennessee. They are the only physicians in Union County. They make less than half the money they could earn in a metropolitan area. They are serving in Union County because they want to provide health care to folk who might have some difficulty obtaining care otherwise. These doctors see their serving in this rural area as an opportunity to live out their Christian faith. The quality of our life-styles indicates to the world if we have decided to deny ourselves.

BILL BRUSTER

Matthew 16:24-26 Save Life

There are very few causes or principles that any person is willing to give his ultimate commitment to. Most everyone is looking for a cause, a purpose, a person to commit their lives to. Instead of standing up and speaking out for Christ as our purpose for living or the person we live for, we try to conceal our moral and religious feelings in such a way that we impress upon others that we are acceptable.

The story is told of a man who was attacked by two robbers. The man put up a desperate fight until finally the robbers pinned him to the ground and searched him for money. To their dismay, they could find only one dime in his pockets. With a sense of frustration combined with questioning amazement, one of the robbers asked the victim why he fought so hard over just one dime, for he came very near getting killed for it. The weary, assaulted man responded that he did not want anyone to know the truth about his financial status!

We put forth an effort to conceal our religious life so that we might save face with God and with others. And in the process of our desperate attempt, we neither have happiness in our own spiritual pilgrimages nor do we have anything to share with others. Few people have the willingness to take a stand, to take up their crosses and follow Christ. They consider enduring the burdens of life common to all people to be the cross they bear for Christ, when in fact that is not his cross at all! The cross of Christ we bear is something we willfully choose

to take up. His cross is not thrust upon us without our desire. We cannot escape human suffering, but we can avoid taking up the cross of Christ and following him daily.

The seeming contradiction of Jesus' teaching in Matthew 16 is that when we try to save our lives we let them slip away through our fingers, while when we are willing to establish a faith relationship with God in Jesus Christ, we find life abundant, meaningful, and lasting—indeed—life eternal!

<div align="right">ROBERT W. BAILEY</div>

Matthew 16:24-26 Discipleship

On the morning of July 27, 1945, in the postwar devastated city of Berlin, Germany, an aged German couple sat listening to a daily radio broadcast from London. They soon realized that a memorial service was in progress. Their anxiety rose as they listened to a single German voice speaking in English. "We are gathered here in the presence of god to make thankful remembrance of the life and work of his servant, Dietrich Bonhoeffer, who gave his life and faith and obedience to His holy Word." The German father reached over and clasped the hand of the German mother, and they wept quietly. Months of wonder and fear and even hope were over, for they knew through that sentence spoken in far away London of the fate of their son, Dietrich Bonhoeffer.

If the German clergyman and theologian had made different choices earlier in his life, he would not have been the person memoralized that day. During the mid-1930s, Bonhoeffer took issue in a radio broadcast with the German chancellor, Adolf Hitler. Later Dietrich led in the founding of two seminaries without the express approval or permission of the Third Reich. But it was his involvement in a plot to assassinate the führer that resulted in his arrest and execution. Bonhoeffer could have chosen to be silent, to cooperate, and even close his eyes and ears to the attrocities and denials of freedom perpetrated by the Third Reich. But prior to his pilgrimage of sacrificial decisions, he had realized that when "Christ calls a man, he

bids him come and die." He had denied himself. He took up his cross and followed his Lord.[54]

JAMES M. PORCH

―――――――◄●●►―――――――

Matthew 16:26 Life

Yale University biochemist Harold Marowitz has calculated the materials in the human body, such as hemoglobin and rare enzymes, are worth $245.54 per gram. In a 168-pound person, the dry weight would be 24,436 grams with a value of over six million dollars. If these materials were synthesized in a laboratory, their worth would be six billion dollars.

Biologically, each person is priceless, but without the life of Jesus "what is a man profited?"

BILL D. WHITTAKER

―――――――◄●●►―――――――

Matthew 17:1-21 Worship and Work

Christians are occasionally tempted to retreat from the world permanently. William James uses a German word to describe graphically the fragmentation and pressure we moderns often feel. *Zerrissenheit* means "torn-to-pieces-hood." It's the experience of being pulled in a dozen different directions all at once.

James Truslow Adams tells a dramatic story about "torn-to-pieces-hood." An explorer was making a hurried trip up the Amazon River. One morning he awoke, intending to push on urgently, and discovered his native laborers were still resting.

When the explorer pressed the native chieftain for an explanation, the chief answered: "They are waiting. They cannot move farther until their souls catch up with their bodies."

The Christian life is a constant rhythm of worship and work, work and worship. We replenish our lives on the mountaintops; we serve

others in the valleys. Refreshment and engagement are both Christian activities.

ROBERT D. DALE

Matthew 17:20 Faith

My grandfather Carter lacked but one week being ninety-eight-years old at the time of his death.

He was past eighty when he took his first airplane ride. He had been visiting one of his daughters who lived in Kansas City, Missouri, and flew from there to Indianapolis, Indiana, to visit another daughter.

On my next visit to him, he told me about the trip. "Son," he said, "I didn't put my full weight down on that seat the whole trip."

That is not faith.

Faith is putting your full weight on God. Faith is trusting God without any holding back, without any restraint, without any reservations.

Many of us practice faith the same way my grandfather rode the airplane. We don't really put our full weight down.

For instance, we may give God our problems through prayer—and still worry about them.

We may turn a situation over to God—and still try to manipulate the outcome.

We may say that we trust God's Word—and still try to second guess the outcome.

We may accept a promise of God—and still try to bring about the result ourselves.

We may say that we accept Christ by faith for salvation—and still try to work our way to heaven.

That is not faith. Faith is belief; it is trust; it is commitment. Faith is giving ourselves completely to God; putting our full weight on him.

JAMES E. CARTER

Matthew 18:1-4 Childlike Faith

Children have a special way of viewing the world. God has given them imagination that sometimes penetrates the external to greater reality. Antoine de Saint Exupéy's classic story of *The Little Prince* provides illustrations of the child's vision. A child takes a simple line drawing to an adult. The adult sees a simple straight line with an uneven hump and concludes, "That is a hat." The child is frustrated that the adult cannot see that the picture is of an elephant swallowed whole by a boa constrictor.[55] The gospel is profundity made simple, but our explanations and preconceptions obscure it. A child accepts love and responds in simple trust. The cross is a simple act of love which is often obscured by philosophical speculation about why.

RAYMOND H. BAILEY

Matthew 18:1-4 Children, Humility

Sometimes we talk of Christianity and Christian service in complicated terms. We tend to make being a Christian and living the Christian life very involved. We get like the disciples were after they had failed to heal the demented lad. We think we need to improve our technique and ask, "Why could not we cast him out?" (Matt. 17:19).

It is not surprising that the disciples later got into a discussion, if not argument, about who was the greatest. When we compare credentials, we become competitors. At any rate, Jesus called a child to him as an object lesson for the disciples (Matt. 18:1-4). I suppose we could say that the lesson was headed "humility." A subhead could have been "teachability." The disciples were not unlike the missionary in India Leonard Griffith writes of.

The missionary came to a remote village to baptize a number of Christians. Among them was a twelve-year-old boy whom the missionary put off because of his age. "But he is our pastor," said the others. Further questions uncovered the fact that the twelve-year-old boy had visited for a time in another village where he attended a missionary school. Upon his return home, he had shared his simple faith with others and many had become Christians.[56]

The missionary doubtless was greater in his understanding of theological subtleties than the native lad. But the lad may have been the more effective evangelist. His friends saw in him that which Jesus said must be found in every follower of his: humility and openness to truth.

RALPH L. MURRAY

Matthew 18:1-6 On Helping the Little Ones

Wayne Oates had said that turnips aren't grown by standing in the middle of the garden yelling: "Grow up! Grow up! Grow up!" Neither do you scream, groan, moan, gnash your teeth, or roll on the ground. You provide turnip seed the proper circumstances and soil and climate and fertilizer and light and rain and, God willing, you'll have turnips.

If we are to train children in the way they should go, we must obey this law of the turnips. We create the proper conditions of love and care. We spend time in the relationship. We give them the gift of ourselves. We open doors to a world and church and God they cannot discover on their own. We provide braces and swimming lessons and medical care. But we go beyond this. We give them the best we have, out of our fragile resources of faith and hope and love, knowing full well how easy it is to harm one of these little ones. And in the doing, a wondrous thing shall happen. They will rise up one day and call us blessed.

ROGER LOVETTE

Matthew 18:1-4 Conversion

Trina Paulus in her intriguing book *Hope for the Flowers,* gave a modern parable about the possibilities of conversion. The parable is the story of a caterpillar who had trouble becoming all he was intended to be. Using two caterpillars, Paulus drew a striking parallel to the human situation.

The story opens with the hatching of a black and white striped

caterpillar who soon became bored with life. He was dissatisfied with eating and getting bigger, so he longed for a greater fulfillment. He engaged in conversations with other caterpillars about the meaning of life. They seemed only to be interested in existence.

One day the black and white striped caterpillar came to a large stack of caterpillars. Each caterpillar was trying to reach the top. Stripe pushed in and joined the struggle to get to the top. He didn't know what was at the top, but he thought that it must be good for everyone was searching and trying for the top.

On the way to the top Stripe met a little, yellow caterpillar who shared some anxieties with him. They talked about the struggle. Stripe and Yellow became friends and decided to give up the climb. They came down through the masses of caterpillars and began to enjoy the freedom of the fields. After a time, Stripe and Yellow became bored with each other. Stripe decided to begin the climb to the top again.

Meanwhile, Yellow encountered a grey-haired caterpillar hanging upside down on a branch. Yellow conversed with the creature and asked why he was in such an ugly position. Grey said that hanging upside down was necessary to become a butterfly. He said that's what caterpillars are meant to become, butterflies with beautiful wings which can fly from flower to flower. Grey told Yellow that she must be willing to give up being a caterpillar in order to become a butterfly. Yellow decided to try it, so she spun herself in a cocoon.

While Yellow spun herself into a cocoon, Stripe continued to climb with determination to the top of the caterpillar pile. Finally, Stripe reached the top only to discover nothing was there.[58]

Life is like the experiences of Yellow. It can be changed. Human beings can get caught up in the existence of life and miss its meaning. This modern parable teaches us to give up our way and give in to God's way. Life will become beautiful.

HAROLD T. BRYSON

Matthew 18:1-14 God's Will

I grew up with a lot of people in the Appalachian Mountains who were comforted with the thought that everything is God's will,

meaning that God caused everything to happen that happened. My study of the Bible shows that God lets us make our choices, for he did not make us to be robots. When I was a college student, someone explained the difference between God's will and God's knowledge.

At that time, I was living in the mountains and was well acquainted with a high mountain behind our town, a mountain so steep the road wound around for five miles before reaching the top at a three thousand feet higher elevation. The person said to me to imagine that I was high up on a mountain early one morning and could see the road winding its way down the side of the mountain. At daybreak I could see a car making its journey to the bottom. I could also see that around a blind curve a flash flood had washed away the bridge the night before. I could know that, when the car rounded the curve to see the bridge over the deep river was gone, there would be no way for the car to stop in time. The car would plunge down into the valley below, meaning almost certain death for its passengers. I could know what was going to happen as I saw the car round one turn after another at that early morning hour, but I could not be the cause of the tragedy. No one would have ever considered blaming that accident on me just because I realized it was going to happen.

God can know what we will do long before we ever do it. God will permit us to do evil and let evil happen to us because we are cut out of the human fabric made of clay. But these facts do not mean that God has mercilessly set for our goal in life misery and sorrow. God wants us to know his love and to love him, thereby sharing his love creatively in his world. His will for us is abundant, joyful living. It is not his will that anyone should perish and not know his loving fellowship, but he does leave us free to choose whether we will accept him or reject him. He does not will that we should sin and destroy our lives, but he will allow us to so live when we turn our backs on him.

ROBERT W. BAILEY

———◄•●•►———

Matthew 18:12-14 Seeking the Lost

Set in the early, savage turbulence of the black liberation movement in South Africa, Alan Paton's novel *Cry, the Beloved Country* is

the story of a loving father seeking a lost son. The Christian father sought his son among the human wreckage of an immoral, oppressive society. The young man sought freedom through revolution. He became a fugitive and a terrorist. He started down a path he thought led to freedom but was the way of self-destruction. The father followed his son's trail of violence and fear which led to the gallows and death. The father finally found his son, too late, on the gallows where he would pay the wages of his sin.

The shepherd seeks the foolish, lost sheep in the wilds, hoping to find it before it wanders off a cliff or is killed by another animal. God seeks the lost with the same love; only he has the power to save from the gallows of sin.

RAYMOND H. BAILEY

Matthew 18:12-14 Evangelism (Lost)

In the future, according to Isaac Asimov, a person need never be lost again. In the coming age of communications where modulated laser light instead of radio waves will carry messages, there will be room for each human being to be assigned a special frequency all his own, like a telephone number. A person lost in a trackless wilderness will be able to transmit a call-for-help signal on a personal frequency and at a fixed intensity. The location can be fixed and a computerized listing can determine who the person is. It is possible that a microunit, that requires a new energy source only once in a long while, can be inserted under the skin. Parents will be able to locate their children by tuning in on their children's frequencies. Kidnapping may become impossible. The oft-asked question, Do you know where your children are now? could be answered with a firm, Yes, just as soon as I turn on my receiver and scanner and read the setting.[59]

This system of detection may not suit teenagers who would rather their parents not know their whereabouts, nosey neighbors who know the frequency, or a wayward spouse who claims to be working late at the office.

The possible breakthrough is a new variation of an old theme: Among animals, a lost young one will mew or bleat or squawk, and the

parent will recognize its own young one's sound among many others and zero in on it at once.

Jesus is tuned to our frequency. Just as he was concerned about the one lost sheep in Matthew 18:12-14, his receiver is one and he's waiting for our call-for-help signal. A person need never be lost again.

JACK GULLEDGE

Matthew 18:21-22 Forgiveness

Surely God does not expect mere humans to emulate divine mercy in the area of forgiveness. Could any human being forgive an offense as grave as unjust murder? Mrs. Goldie Mae Bristol did. Her daughter Diane was brutally raped and murdered in San Diego in 1970. Mrs. Bristol turned to God for guidance, and she received a special measure of grace. Several years later she stood before seventy inmates at a California prison facility and told those present that she had not only forgiven her daughter's murderer but had also come to love him. After she and Mr. Bristol had spoken, Dennis Keyes walked forward and identified himself to the group as the confessed and convicted rapist and slayer. God's love is more powerful than hate and revenge.

RAYMOND H. BAILEY

Matthew 18:21-22 Forgiveness

Thomas Jefferson and John Adams were friends. They sat together in the Continental Congress, and both helped write the Declaration of Independence. Mrs. Adams assisted the widowed Jefferson in preparing for the arrival of his daughters in France. Each of the men served the United States government at the same time, Adams as the first vice-president and Jefferson as the first secretary of state. But both wrote essays espousing different views concerning the French Revolution; and, immediately, a cleavage in their friendship began. Adams was elected president, and Jefferson was his vice-president. But following the first week of the Adams's administration, the men did not speak to

each other. Jefferson succeeded Adams. The night before Jefferson's inauguration Adams appointed some members of the Federalist party as judges. Jefferson had planned to make these appointments his first day in office. The friendship was totally severed.

Ten years later, Ed Cole visited both former presidents and attempted to awaken in each of them some semblance of mutual care for each other. As a result of Cole's intervening efforts, the men began writing each other and in their own way forgiving each other. In his first letter Adams wrote, "You and I ought not to die until we have explained ourselves to each other." During the remaining years of their lives, they exchanged 158 letters that are today a classic repertoire of American history.

On the morning of July 4, 1826, fifty years to the day after the signing of the Declaration of Independence, Jefferson and Adams lay dying. Jefferson died first, Adams died a few hours later. They were hundreds of miles apart. But both died forgiven.[60]

"Lord, how oft shall my brother sin against me, and I forgive him?" . . . "Until seventy times seven."

JAMES M. PORCH

Matthew 18:21-35 Forgiveness

Martin Niemöller was held as Hitler's personal prisoner for eight long years during World War II. At first, his only thought was of escape or release. But as the months wore on into years, Niemöller's perspective changed. He began to think about the importance of forgiveness.

The gallows was in plain view outside his cell window at Dachau, and day after day Niemöller watched men and women die. The daily scene through that window haunted him with questions: *What will I do when they put me to that test? What will be my last words? Will they be, 'Father, forgive them,' or "Criminals! Scum!"?* Niemöller confessed that the gallows became his teacher, and it taught him forgiveness. The lesson sank home one day when the thought came that if Jesus had cried out in vengeance and hate against those who abused and killed

him, there would have been no New Testament, no church, and no Christian history. Forgiveness is that important![61]

Jesus taught in Matthew 18:22 that forgiveness must have no limits. He went on with a story which makes the point that God's forgiveness of us is linked with our forgiveness of others. We must forgive to be forgiven.

Andrew Jackson, America's colorful and vigorous seventh president, married a daughter of Colonel John Donelson after her divorce from her first husband, whom she had married in Virginia. In the campaign of 1828, it was discovered that the divorce decree had not been granted by the Virginia courts, and General Jackson and his wife were subjected to the most virulent personal attacks by his political opponents. His wife lived to see her devoted husband elected president, but she did not live long enough to see him go to the White House.

Some years later, after the general had retired from public life, he was being examined by his minister as to his faith and experience prior to baptism and church membership. In view of his many quarrels, his feuds, and his stormy career, the minister asked: "General, there is one more question which it is my duty to ask you. Can you forgive all your enemies?"

After a moment's silence, Jackson responded: "My political enemies I can freely forgive; but as for those who abused me when I was serving my country in the field, and those who attacked me for serving my country, and those who slandered my wife, Doctor, that is a different case."

The minister made it clear to the general that none who harbor ill feelings against a fellow being could make a sincere profession of faith. Again, there was silence until, at length, the aged candidate said, in effect, "I will try, Doctor, to forgive all my enemies."[62]

RALPH L. MURRAY

————◄●●►————

Matthew 18:21-35 Forgiveness

Jesus emphasized the importance of forgiveness in a moving story in Matthew 18. He spoke both of forgiving and seeking forgiveness.

An interesting incident in Billy Graham's ministry illustrates again the place of forgiveness in every Christian's life.

One of the celebrated converts in an early Graham crusade was Jim Vaus. He reportedly had connections with organized crime, and his conversion led to a radical change in life-style. Vaus was a wizard at electronics and suggested to Graham that he had an idea that might help him on his initial "Hour of Decision" broadcast. The idea was to use a wireless microphone which would give Graham freedom to move about the platform.

Graham liked the idea and decided to try it. But all did not go as planned. The rubber-covered antenna wire connected to the microphone was exposed. Every time it hit Graham's leg, it gave him a good shock.

Vaus had never seen Graham even slightly angry with anyone. But after the service, Graham went to Vaus and told him off in no uncertain terms. The next morning Vaus found a note slipped under his door. It read, "Please forgive me for my anger. I couldn't love you more if you were my own brother. Billy."

The genuineness of Graham's faith was evident. We must not just preach about forgiveness. We must seek it from those we've wronged and extend it graciously to others.[63]

ERNEST D. STANDERFER

Matthew 18:21-35 Forgiveness

In his novel, *Love Is Eternal,* Irving Stone presents a narrative account of a conversation between Mary Todd, the wife of Abraham Lincoln, and Parker, the president's bodyguard. Parker, a heavy-faced man with half-closed eyes, entered and trembled before Mrs. Lincoln. "Why were you not at the door to keep the assassin out?" she asked fiercely.

"I have bitterly repented it," Parker answered, his head hung low. "But I did not believe that anyone would try to kill so good a man in such a public place. The belief made me careless. I was attracted by the play, and did not see the assassin enter the box."

"You should have seen him," she cried. "You had no business to be careless." Falling back on the pillow, she covered her face with her hands. "Go now. It's not you I can't forgive, it's the assassin."

"If Pa had lived," Tad, the son, said, "he would have forgiven the man who shot him. Pa forgave everybody."[64]

The parable of the unmerciful servant is the story of a man who has been forgiven a large debt but who then refuses to forgive a lesser debt which is owed to him. Jesus noted the terrible nature of mercilessness in the picture of the punishment which is given to the servant. The greatness of God's mercy is "from everlasting to everlasting," and it is infinite and as vast as the ocean. As God has shown his mercy toward us in forgiving us our sin, so we in turn should be merciful and forgive those who have wronged us.

WILLIAM P. TUCK

Matthew 18:33 Mercy

Mercy received ought to issue in mercy given. In the *Merchant of Venice,* Shylock asks Portia, "On what compulsion must I [be merciful]? tell me that."

Portia answers:

> "And earthly power doth then show likest God's
> When mercy seasons justice. Therefore, Jew,
> Though justice be thy plea, consider this,
> That, in the course of justice, none of us
> Should see salvation: we do pray for mercy;
> And that same prayer doth teach us all to render
> The deeds of mercy."[65]

The man in Jesus' story had just received mercy from his master. Yet he turned from a deed of mercy to demand full payment from one who owed him far less. I expect each of us can identify with this merciless servant whose experience of forgiveness had not affected his own spirit. We can identify with him because too often we have expressed his attitude, and we live in a society that thrives on his

philosophy of life. We who have been saved by grace become rank legalists in our dealings with others.

JAMES A. YOUNG

———◆◆◆———

Matthew 19:1-12 Marriage and Divorce

According to news reports from Seattle, a husband wrote a love poem to his wife, placed it in an envelope with a ten cent stamp, and dropped it into the Pacific Ocean. That was more than a decade ago. The poem said, "If by the time this letter reaches you, I am old and gray, I know our love will be as fresh as it is today. I will go to any extremes to prove my love."

The letter reached Guam and was returned to Seattle, but it could not be delivered. A newspaper there found the woman, phoned her, and read the poem to her. She laughed and told the caller, "We're divorced."[66]

Jesus taught that marriage is holy. If we believe in the holiness of marriage, our promises will surely be more deeply rooted and more permanently established.

W. WAYNE PRICE

———◆◆◆———

Matthew 19:3-9 Lifelong Faithfulness

The biblical ideal for marriage is one man for one woman for life. Faithfulness is the foundation for Christian marriage.

Winston Churchill was honored at a banquet and was asked questions by the audience. One guest asked Churchill who he would choose to be, excluding himself, if he were given another lifetime.

Smiling down at his wife, Winnie, he quickly replied: "I would choose to be Mrs. Churchill's second husband." Faithfulness provides the backdrop for sound relationships.

ROBERT D. DALE

———◆◆◆———

Matthew 19:3-9 Divorce

The once unthinkable action of divorce is now largely accepted as an option. Suzanne Britt Jordan wrote, "I think people should be upset about so serious a thing as divorce. . . . I'm grown up; I have responsibilities; I am in the middle of a lifelong marriage; I am hanging in there, sometimes enduring, sometimes enjoying. For some reason, we assume that people can't stay married for life, but we make no such assumption about staying on the same job, keeping the same religion or voting the same ticket."[67]

Jesus affirmed the principle of permanence for marriage. "What therefore God hath joined together, let not man put asunder."

BILL D. WHITTAKER

Matthew 19:6 Marriage Unity

Shared values contribute much to marital unity. Barbara Myerhoff tells of visiting in the home of an eighty-year-old Jewish couple. "Look at our home," said Rebekah. "It is nothing fancy but filled with books, filled with ideas and love." When asked how they met, she answered, "You see we had the same background. Shmuel was in the Bund with my brother. One night we were at the same meeting and that same night we walked out hand in hand. That's how we walked."

Shmuel nodded. "Since then, that was fifty-four years ago, we've been holding hands together. That's why I could never make a lot of money. I wanted to hold her hand always."[68]

J. DANIEL DAY

Matthew 19:13-15 Forgiveness

The mind of a child ties together such major issues as forgiveness, repentance, and the kingdom of God. The late Dag Hammarskjöld somewhere in his meditations made that connection. He suggested that forgiveness is the answer to a child's dream of a miracle by which the broken is made whole and the soiled cleansed. The dream, he

wrote, explains our need to be forgiven and to forgive. In God's presence, nothing stands between him and us; we are forgiven. But we cannot feel his presence if anything is allowed to stand between ourselves and others.

W. WAYNE PRICE

Matthew 19:16 Life

The broadway play *Man of La Mancha* is based on the life of Miguel de Cervantes. It is set in a sixteenth-century Spanish prison in Seville. The play opens with Cervantes being cast into prison because of his actions during the Spanish Inquisition. During a mock trial, Cervantes assumes the role of Don Quixote. The play is centered around the moving song, "The Impossible Dream."

We often dream of life in all its fullness, as the rich, young ruler dreamed of life. But how many of us are willing to pay the price. The rich, young ruler came running to Jesus because he recognized in Jesus the source of life that had alluded him. But he went away sorrowful because he could not put his trust in Jesus as Christ demanded.

JAMES A. YOUNG

Matthew 19:16-22 Costly Grace

A lot of people think that God asks too much of them. Like the rich, young ruler, there are things they would rather have than eternal life. In Shakespeare's play *Hamlet,* the king, who has murdered his brother and married his brother's wife and usurped his brother's kingdom, struggles with the results of his wicked acts. Like many of us, in spite of this dreadful behavior, he goes through the routine of his evening prayers. He struggles to pray. He kneels, casts himself down on the floor, and finally cries out with great agony and anguish that his prayers seem to bounce off the ceiling. But he knows why his prayers choke in his throat.

"Pray can I not,
Though inclination be as sharp as will:
My stronger guilt defeats my strong intent."

The king concludes that he cannot know forgiveness as long as he is unwilling to give up the benefits of his sin.[69]

We want forgiveness but without repentance, without change in our lives, without giving anything up. It cannot be.

RAYMOND H. BAILEY

Matthew 19:22 Decisions

Viktor Frankl, having survived the harrowing concentration camps of Auschwitz and Dachau during World War II, discovered upon regaining his freedom that most of his family had been killed in the holocaust. That discovery, added to his prison experiences, led this medical doctor and psychiatrist to establish a new approach to inner life. He asserted that humanity's basic drive is not sex, not power, but the search for meaning in life. He called this new approach logotherapy.

In his explanation of the phrase "meaning in life," Dr. Frankl has written: "To ask the meaning of life in general terms is to put the question falsely because it refers vaguely to 'life' and not concretely to 'each person's own' existence . . . (We) give the question of the meaning of life an entirely new twist. . . . It is life itself that asks questions of man. . . . He has to respond by being responsible; and he can answer to life only by answering for his life."[70]

The answer given to life (and to Jesus) by the rich, young ruler in Matthew 19:22 was inadequate. Having chosen that which fails, he could only have come in time to a confusion similar to that of certain race dogs on a Florida dog-racing track. The mechanical rabbit, which runs around the track as a lure for the dogs, blew up and disappeared. The dogs went crazy and showed all the signs of nervous breakdown. The whole purpose of their existence was gone, and the goal they had been chasing betrayed them.

Wrong decisions and wrong answers to life have a way of doing

that. Our decisions, our answers to life, must answer for life. "We must respond by being responsible."

RALPH L. MURRAY

Matthew 19:24 Riches

When Jesus taught that it is difficult for a rich person to enter heaven, he probably was talking more about attitude toward money than money itself. If a person idolizes wealth and measures life only in what money can buy, then he will sense little need in trusting Christ for eternal life.

When Robert Santway was running for Congress from Vermont in 1976, he listed personal "assets" totaling nearly $1 million. For example, he placed a value of $100,000 on his personal health. As an asset, he also listed $50,000 for the well-being of his family, $10,000 for his friendship with tenants of a housing project, $25,000 for four years of teaching Sunday School, and so on.[71]

Surely it's this type of "wealthy" individual who is more likely to trust Christ than those of dollar wealth who may be too ego-centered to think they need any faith except what they have in themselves and their ability to earn a living.

ROBERT J. HASTINGS

Matthew 20:1-16 Work

In 1894, Congress designated the first Monday in September as "Labor Day." Work in America has changed dramatically during the years since. We have gone from a twelve- to an eight-hour workday (unless you are in management). We have gone largely from physical toil to the use of technology. We have moved from mechanization to automation to cybernation (linking computers to machines). Now, there is a revival of interest in handcrafts.

The Protestant work ethic has helped make our nation great. The

theology of work does not view work as a curse but as a blessing. We work not simply for pay but in order to help and serve. At its highest, work is done for the glory of God. Our work becomes our offering to him.

ALTON H. MCEACHERN

------◄●►------

Matthew 20:20-28 Service

At the close of the Revolutionary War, American soldiers became impatient with the insensitivity of congress to their needs. They suggested that the army set up a monarchy and make Washington the king.

Washington finally met with a group of soldiers and spoke about the values of their democratic government. He called for patience, believing they would be treated justly in due time. When he finished speaking, it was evident that he had made little impact on the soldiers' thinking. He then remembered that he had brought a reassuring letter from a congressman. As he pulled the letter from his pocket and prepared to read it, he stopped and seemed confused. The officers waited anxiously. Finally, Washington pulled from his pocket something that only a very few had seen him use—a pair of glasses. "Gentlemen," he said, "you will permit me to put on my spectacles, for I have not only grown gray but almost blind in the service of my country."

That simple act and statement did what his arguments had failed to do. Many wept at the realization of his sacrificial service. They listened, and the country was saved from civil discord and possible tyranny.[72]

There is no substitute for genuine service in the name of Christ. As we serve and minister to the needs of others, we are following Jesus' clear teaching. Even more, we are following the example of his own life and ministry.

ERNEST D. STANDERFER

------◄●►------

Matthew 20:20-28 Greatness

The Status Book lists ways in which virtually anyone can achieve public esteem and status. Author Gary Blake offers these suggestions: insure your property with Lloyd's of London; become a delegate to a national political convention; write a song and have it copyrighted; have an audience with the Pope.

Jesus' criteria for greatness was childlike trust (Matt. 18:4) and service to others. This is certainly opposite to the standard for status panhandled to today's market place.

BILL D. WHITTAKER

Matthew 20:26-28 Redemption

Kay DeKalb tells of a conversation with a friend of hers. The woman told Kay about her seven-year-old daughter's interest in Christ. The girl told her mother that she wanted to become a Christian.

"Why?" her mother queried.

The little girl responded, "Because of what Jesus did for me on the cross."

Wanting to test her child's understanding, the mother took the questioning one step further: "And honey, what did Jesus do for you?"

The little girl replied with a spark in her eye, "He looked down at me and said, 'You're valuable,' and then he bought me!"

The purpose of Jesus' coming was to redeem us from our sin. He explained this to his disciples as he approached Jerusalem for that fateful encounter with the religious leaders: "Whoever wishes to become great among you shall be your servant, and whoever wishes to be first among you shall be your slave; just as the Son of Man did not come to be served, but to serve, and to give His life a ransom for many" (Matt. 20:26-28, NASB). Jesus bought us with a high price to let us know that we were valuable to him.

BRIAN L. HARBOUR

Matthew 20:29-34 Compassion

On the morning of June 27, 1981, Gerard Coury jumped onto New York City subway tracks and died, either from electrocution or fright. The police had earlier found him wandering in a train station, shoeless, shirtless, the victim of a mugging. Earlier Coury made a phone call to his parents and then to an uncle receiving a promise of help. But by the wee hours of morning, the help had not come. Coury apparently wandered back into the street and became the victim of the taunts of the street people. They stripped him of his trousers and chased him into the Times Square Station where he became a victim of collective violence, devoid of mercy.

In a large city, both need and violence seem to be intensified by volume. But cries for mercy, audible and silent, are all around us. They were all around Jesus. Jesus' friends often tried to protect him from such distress; some followers shunned the needy for other reasons. Jesus, however, seems never to have turned a deaf ear. "What do you want me to do for you?" he asked Bartimaeus (v. 32, RSV). A little bit of compassion changed many lives, just as dramatically as the absence of a little bit of compassion apparently drove Gerard Coury to a horrible death.

W. WAYNE PRICE

Matthew 21:28-32 Obedience

It is not what we say but what we do that matters. Once a flock of geese lived in a certain barnyard. Each Sunday these geese would gather together in the shade of the barn to hear the gander preach of the glorious destiny of geese. The moving oratory of their gifted leader would raise the feathers on their backs as he reminded them of the purpose for which their Creator had made them—namely flying. Week after week they were told of the thrill of soaring above the earth. But each week they returned from their meeting to a daily routine of eating and growing plump and delicious. At Christmas they were eaten without ever knowing the exhilaration of ascending toward the sun and gliding through the clouds.

This parable, created by the nineteenth-century philosopher Kierkegaard, illustrates the difference between talking about faith and living it. Kierkegaard called his tale "The Domestic Goose." The scene has a depressing familiarity for most of us. We know too many "domestic" Christians who gather on cushioned pews in air-conditioned, religious palaces each week to hear the truth of the kingdom of God. On Monday they return to lives that give no evidence of the glorious destiny of citizens of that kingdom.

RAYMOND H. BAILEY

Matthew 21:42 Jesus Christ (a Rejected Stone)

In the early 1930s, Louis Comfort Tiffany, son of the founder of Tiffany and Company, established a six-hundred acre estate known as Laurelton Hall on Long Island as a refuge for aspiring young artists. Tiffany's Art Nouveau mansion included his vast collection of windows, chandeliers, paintings, and various glass objects. By the time of his death in 1933, public opinion about both his art and the estate had declined. After years of neglect, vandalism, and a fire, what remained of Laurelton was facing a wrecker's ball.

Hugh McKean was one of the young artists who lived and worked at Laurelton in 1930. In 1957, he interceded and decided Tiffany's work deserved better than demolition. Together with his wife, Jeannette, he crated most of what remained of the house—including architectural pieces and Tiffany's collection of vases—and shipped them to his home in Winter Park, Florida.

During the past decades, Tiffany's work has again received recognition. The Morse Gallery in Orlando, Florida, houses the world's most comprehensive collection of the work of Louis Comfort Tiffany. His once-scorned creations now command prices ranging in excess of $100,000. Some of his work is on loan to the Metropolitan Museum in New York City where the huge loggia that was once the entrance to Laurelton Hall now provides the focal point for the new American wing.[73]

In Matthew 21:42, Jesus talked about a rejected stone. Recalling Psalm 118:22, he said the stone which was rejected became the most

important stone in the whole building. William Barclay has said that Jesus is the foundation stone on which everything is built and the corner stone which holds everything together.

JACK GULLEDGE

———————————

Matthew 22:15-21 Citizenship

Most of us find it hard to know the proper approach to take toward patriotism to insure wisdom and morality at the same time. We tend to go from one extreme to the other, or else we avoid all contact with and all conflict with politics altogether.

Once Linus said to Charlie Brown that he did not like to confront problems head-on. He had decided the best way to solve problems was to avoid them! He felt there was no problem so big or complicated that it could not be run away from! When Charlie questioned what the world would be like if everyone ran away from their problems like Linus, the little guy concluded that at least they all would be running in the same direction if they were running away from their problems!

It seems that Christians are taking a mass exodus from political involvement as Christian citizens or else they are seeking to turn their church into a political party. While proclaiming Christ as their Lord, we have people in all church memberships who never participate in the experiences and life of the church.

We need to say to our church members that they are members of the kingdom of God as well as citizens of our nation. The government expects and Jesus taught that obedience to civil law can be quite good, for peace can be maintained. But at the same time, Jesus urged his followers to keep the right priorities and distinctions in their dual citizenships. We need not run away from the problems of our government and society, just as at the same time we need not try to take over and dictate our brand of religious morality to persons who have their own choices to make. We must learn to be faithful citizens to both kingdoms, remembering always that Christ is Lord and he is the Head of our homes and churches.

We do not impress Christ if we refuse to know or do anything about our government. Likewise, we do not please him if we try to set

up a dictatorship under our command. As Christians always, wherever we are, we need to be giving clear witness that we have joint membership in the citizenship of our nation and the Father's kingdom. And at the same time, we need to communicate that we will be uppermost citizens in both kingdoms.

ROBERT W. BAILEY

Matthew 22:34-38 Love

The best known Scripture portion in Jesus' time was, no doubt, Deuteronomy 6:4-9. It was called the Shema. The word *Shema* is the first word of the passage and means, "Hear thou!"

A devout Jew would recite the Shema the first thing in the morning and the last thing at night. He would also carry writings of this passage in two small cubical leather cases, worn on his forehead and his left arm. In this way, he kept the instruction in these verses in his mind and close to his heart. A Hebrew home would have these verses in a small container called *Mezuzah* which would be attached to the doorjamb. A person going through the door would touch his fingers to his lips and then to the Mezuzah as a sign of his devotion to this command.

When asked to name the greatest commandment of the Law, Jesus quoted Deuteronomy 6:5, the central instruction in the Shema. It may seem that the man asked Jesus a question whose answer was obvious. However, we must not feel superior to the man since we may be just as heedless about that command and about obeying other teachings of Jesus.[74]

The command of Jesus to love God and to love our neighbor calls for us to define love. Frank Stagg has said, "Love is the basic disposition of one's whole being to relate to God for his glory and to man for his good."[75]

ELMER L. GRAY

Matthew 22:34-39 Love

Martin Buber was a versatile Jewish scholar and a primary religious thinker of the twentieth century. Most of his life he carried an agonizing weight of concern for the strained relationships existing among people. He believed people could meet each other with genuineness and integrity. This conviction was born as he rejected the political manipulation of Zionism and embraced Hasidic Judaism. He discovered in his studies of Hasidim the meaning of Old Testament loving-kindness. People must meet people in acts of love.

Buber began to write. His works constantly pursued the theme of challenging people to improve their relationships with others amid an age of suspicion and faulty communication.

Buber died on June 13, 1965. The following day a *New York Times* memorial editorial attempted to sum up his life. "Because Martin Buber lived, there is more love in the world than there would have been without him. And for him that was the reason above all others for the gift of life."[76]

One time the Pharisees questioned Jesus concerning the great commandment. His answer focused directly on the relationships of love he expected of his people. One who distinctly seeks to love self, God, and neighbor will give this world more love than "if he had not lived."

JAMES M. PORCH

Matthew 23:1-24 False Religion or Motive

How tragic that the greatest opponents to Jesus and the gospel were the religious leaders of Israel. This ugly reality has been often repeated in Christian history. It is possible to be very religious and do all the external acts of charity and still not be guided by the spirit of Christ. T. S. Eliot's play *Murder in the Cathedral* is the story of Thomas Becket. Becket, a leader of the Church of England in the twelfth century refused to compromise his faith to support the policies of the king. Friends of the king set out to assassinate Becket. Becket learns they are on the way to take his life. In the play, several tempters appear to Becket. One comes to suggest that Thomas should compromise and

go along with the king. A second urges Thomas to take worldly power. The third suggests opposing force with force. All of these Becket is able to resist with little effort. The greatest temptation is that of the fourth tempter who encourages Thomas to seek the martyr's death that he may heap down coals on the heads of his enemies and become a revered saint. Thomas concludes what religious people need to be continually reminded, that it "is the greatest treason: To do the right deed for the wrong reason."[77] Motive is all important in religion.

RAYMOND H. BAILEY

Matthew 23:25 Religious Ritualism

From Barbara Myerhoff's captivating study of Jewish old people living in a California ghetto comes this modern rebuke to ritual religion. Hannah, an elderly Jewess is speaking of what it means to be a Jew.

"Some people would say being a Jew is how you follow the laws. Some people would say, like Olga, it's from inside. I will give you a little *myseh* [Yiddish for 'story' or 'folk tale'] on this. In my town was an old lady who was a miser, very big. Nobody was getting a penny from her. She had money all right. She kept strictly kosher and more so when she was getting older. More strict every day. Dishes she had, you couldn't count them. Sinks, pots, spoons, everything she had separate. (Separation of all cooking ingredients and implements for meat and milk products is required by Jewish Law.) One day she went to the rabbi and asked if when she died God would think she was a pious Jew. 'Well,' he told her, 'I don't know what kind of Jew He'll think you are, but certainly He will say you got a very pious kitchen.'"[78]

J. DANIEL DAY

Matthew 23:23-28 Hypocritical Facades

While visiting in Los Angeles, I had the opportunity to see Universal Studios. I was amazed to learn that studio has over five

hundred different sets on their outside studio lot. There is very little real about those sets. Only the fronts of the buildings are erected—they are hollow or nonexistent behind. With just a few cosmetic changes to the streets, the producers can change the city, the nation, even the century they are filming—when in fact it is still the very same street! There seemed to be no end of the facades in that filming studio.

The inside filming is done largely on fake sets which have what is called a "wild wall." This is the opening in the room where the camera is doing the filming. And in order to convince the viewer that he is seeing a real room, a different wall is taken out from time to time so that the camera can change angles. Each time, three fake walls are in view, and since a camera has no depth dimension, the viewer feels like he is actually in a real room.

Everything and everyone are not what they appear to be. But until and unless we learn to see through and correct the masks, we may wind up not realizing how we are, who we are following, or who God is calling us to be. During the days prior to his crucifixion, Jesus uttered some profound words that are recorded in Matthew 23. Each of these seven statements begin with the word translated *woe*. To his own people whom he loved and sought response, Jesus addressed the religious leaders with the admonition that they must give account for their intricate facades, their complicated masks. Because Jesus sees right through us, he indicted the religious piousity of those who were so slick on the outside but hollow within, just like a cup that is clean on the outside but caked with filth on the inside.

Jesus sounds his "woe" or "alas" to us today, for he also sees right through us and calls us to lay aside our hypocritical facades and be genuine before him, instead of dwelling on our pretenses. While we may fool some of the people all of the time and all of the people some of the time, we never fool Christ at all! He knows who we are within, and he calls us to be genuine without any fakery.

ROBERT W. BAILEY

———◄●●►———

Matthew 23:27-28 Simulation (Hypocrisy, Pretense)

A chaplain had talked to a sergeant for weeks about his

relationship to God. One day the chaplain, the sergeant, and others got together for a volleyball game. When the sergeant stripped to his waist for the game, there was the Lord's Prayer tattooed on his chest—every line of it. The chaplain was stunned. There was the Lord's Prayer, but all on the outside. Its message had obviously not sunk in![79]

Jesus' warning to the Pharisees against pretending, against simulation faith in God, needs to be sounded forth again and again. Commitment to Christ must be genuine and love for God must be expressed from the heart.

ERNEST D. STANDERFER

Matthew 24 Tribulation

A growing number of people in America are making preparation for survival in the last days. The prospect of human-made disasters, economic collapse, or natural catastrophes has created a market for "survivalists." Bill Pier of Pier's Survival, Inc. of California has a million-dollar warehouse of freeze-dried foods, water purifiers, and radiation suits. Howard Ruff offers a four-day survival school for up to $400. Other survivalists advise a personal firearms arsenal, rural hideaways, investments in diamonds or real estate.[80]

Survival in the last days will come to the "elect" (v. 31) who shall be gathered unto Christ, whose coming the faithful have anticipated and prepared for (vv. 42-46).

BILL D. WHITTAKER

Matthew 24:29-30 Second Coming

When I was about nine years old, my father told me that he had seen Halley's Comet as it swung around the sun and came within fourteen million miles of the earth.

His experience of seeing the comet had happened over fifteen years earlier but his description was so vivid that I didn't realize it had occurred so long ago.

He said the comet was due back in eighty years. I began to hope I could live to see it on its return. From a child's perspective and with a limited understanding of the comet's schedule I estimated that I would be over ninety when it came back again. Since I wrongly presumed I would have to live to be ninety, I thought I probably wouldn't make it.

In recent years, scientists have given thought to preparing a space vehicle to study Halley's Comet on its return.

I was surprised to learn that the comet was expected much sooner than I had thought. Astronomers say it will be back in 1986. I became excited. That's just a few more years, and I might live to see the reappearance of the comet that thrilled my father so much before I was born.

How had I miscalculated the time? I suppose it was because I made my estimate as a child. Then, incidentally, I had understood its return to be figured at eighty years when it was seventy-six. That made a little difference too.

Anyway, Halley's Comet is returning soon, and I may stand in the yard as my father did and see it come.

But more certain and more significant is the return of Christ the Lord. Much is said in the Scriptures about his coming to the earth again.

From our present perspective, we can't tell when it will be. Many have set dates and missed it, and people are still setting dates. I know this: his coming is now nearer than it was when I was younger.

I shall not miss seeing the return of Christ. Death may prevent me from seeing the comet come back, but it will not keep me from meeting Christ at his return. I have God's Word for that, and I shall see and meet my Lord when he comes.

ELMER L. GRAY

Matthew 24:36 Second Coming

James Watt, interior secretary under President Reagan, is a devout charismatic Christian from Denver, Colorado. He has joined the list of many who have gotten themselves into trouble over comments about the return of our Lord. He made the statement, "I don't know how

many future generations we can count on before the Lord returns."[81]
Secretary Watt was accused of a lack of concern in protecting the
environment. Some of his critics believe he is not concerned about
protecting the environment because of his faith that the Lord will
return soon. Jesus made it clear that no one knows when he would
return. We would do well to do much less predicting and much more
preparing.

BILL BRUSTER

Matthew 25:1-13 Prepared

The Boy Scouts of America have a very clearly stated motto, "Be
Prepared." It is engraved on the Scout badge. The early training I had
in Boy Scouts made me aware of the importance of being prepared.

Years later when I entered Southwestern Baptist Theological
Seminary, I enrolled in Greek class under Dr. Curtis Vaughan. Most
Greek professors began their lectures as soon as the bell rang, but not
Dr. Vaughan. His custom was to begin class by calling on a student to
phrase a verb or decline a noun. Since no one knew who he would call
on, the students were better prepared for his classes than any other
classes I attended.

Shakespeare wrote in *Julius Caesar*:

"There is a tide in the affairs of men
Which taken at the flood leads on to fortune
Omitted, all the voyage of their life
Is bound in shallows and in miseries.
On such a full sea are we now afloat
And we must take the current when it serves,
Or lose our ventures."[82]

The admonition, Be prepared, is sounded throughout God's
Word. We do not know the moment when everything important to
us—our careers, our successes, our hopes, our dreams—will vanish.
We do not know when the bridegroom (Christ) will come. Therefore,
we must be prepared. Every single hour of our lives is marked with this

one unpredictable moment when we must stand alone and face Jesus Christ—prepared or unprepared.

JAMES A. YOUNG

Matthew 25:13-30 Usefulness

Jesus' parable of the talents teaches that what we do not use, we lose.

Though past the age of seventy-five, comedian Bob Hope is still very active. His life has been filled with activity bringing a smile to GI's during World War II, the Korean War, and the war in Vietnam. The comic has become a multimillionaire, but he has not been turned out to pasture just because he is a senior citizen.

At seventy-five, he was still making 250 appearances a year and traveling 250,000 miles. His great usefulness continues in the trade of entertainment.

We must live usefully to keep our physical and mental ability. Use God's gift or we will lose it.

ALTON H. MCEACHERN

Matthew 25:31-46 Accountability

Adolf Eichmann, a native of Adolf Hitler's hometown in Austria, was the director of the office of Jewish immigration for the Third Reich during World War II. His philosophy and action resulted in the extermination of several million Jews. He even boasted, "I will leap into my grave laughing because the feeling that I have five million human beings on my conscience is for me a source of extraordinary satisfaction."

In the final days of the war, Eichmann fled from Germany. He went first to Austria but eventually made his way to Argentina and escaped detection for over a decade.

In 1960, following three years of clandestine operations, David

Ben Gurin announced that Adolf Eichmann had been captured and would be brought to trial.

The trial lasted eight months. During the proceedings, thousands of pages of documented evidence were presented. Eichmann himself was interrogated for hours. Throughout the questioning, Eichmann would not accept responsibility for the executions. He contended that he was a puppet, had acted as a machine, and was carrying out orders. He never admitted or recognized his accountability for anything pertaining to the holocaust.[83]

According to Jesus, some on the day of judgment will ask, "Lord, when saw we thee an hungered, or athirst, or a stranger, or naked, or sick, or in prison, and did not minister unto thee?"

Then shall he answer them, saying, "Verily I said unto you, Inasmuch as ye did it not to one of the least of these, ye did it not to me. And these shall go away into everlasting punishment."

JAMES M. PORCH

Matthew 25:34-36 Service

Christmas can come to a person in need every time his needs are met. Christians everywhere could experience the joy of service by being Santa Claus to people in need. In 1981, Ray Villarreal was named "Humanitarian of the Year" by the Italian-American National Hall of Fame. He won the award because every Sunday he goes to Ciudad Juarez, Mexico, to help the crippled people of that city. Ray fits people with artificial limbs and is also a pedorthist, a person who examines feet and fills doctor's prescriptions for corrective shoes. Every Sunday he delivers shoes and artificial limbs to needy people, sometimes seeing up to fifty people per Sunday. He also gives shoes and clothes to needy children in Juarez and El Paso at Christmas. He gets some donations, but he said, "I still pay about ten thousand dollars to twelve thousand dollars, maybe twenty thousand dollars, of my own money every year, but I'll tell you something. I've found that money is round. Spend it in the right direction, and it will come back to you."[84] Ray Villarreal is simply doing what every Christian ought to do.

BILL BRUSTER

Matthew 25:37 Sharing

In describing the final judgment, Jesus told how the righteous, as well as the wicked, will plead that they never "saw" him so they could minister to him.

"Lord, when saw we thee?" will be the question on many lips since most people have never seen the Lord in the flesh.

The obvious answer is that when we see, and meet, the needs of others, we are "seeing" and ministering to Christ himself. Many of us are so blinded with self-interest that we do not see needy people!

I realized this one day in a drugstore in downtown Springfield, Illinois, when I saw a young woman with a terribly deformed face. Our eyes met, and in returning my gaze, she seemed to beg, "Why are you looking at me that way? I already know my ugliness is repulsive to you." I was immediately convicted, for my eyes had conveyed curiosity but apparently little concern.

ROBERT J. HASTINGS

Matthew 25:41,46 Hell

Los Angeles Times writer John Dart asks, "What ever happened to hell?" and observes, "hell's not the burning question it was." Religion analyst Martin Marty says studies show that "only one in eight who believes in hell believes it is a threat to him."[85]

We can agree with public opinion or Jesus who said, "And these shall go away into everlasting punishment: but the righteous into life eternal."

BILL D. WHITTAKER

Matthew 26:1-13 Giving

Ernesto Perez was a deacon in a little Baptist church in rural Guatemala. He once taught missionary Clark Scanlon an important

lesson in Christian giving. Ernesto's house had a floor of dirt, a roof of thatch, and walls of cornstalks. He earned his living through a beautiful vegetable garden irrigated with water from a mountain stream.

During the weeks that Scanlon served as interim pastor of Ernesto's little church, a good relationship developed between the two men. He shared with the missionary the progress of his garden, especially his cabbage crop.

One Sunday evening, as Scanlon prepared to return to his home, Ernesto stopped him. In a moment, he brought a huge head of cabbage and handed it to his pastor. "Here is the biggest head; I have just picked it, and I want you to have it."

The missionary confessed to several thoughts that ran through his mind. He knew that Ernesto needed the money from the sale of that cabbage, but he also knew that Ernesto was giving something to God's work by giving to the missionary. Ernesto seemed to be saying, "Here is the first, the biggest, and the best of my crop, and I want it to be dedicated to the Lord." Tears came to the missionary's eyes as he reflected on his friend's desire to give his best.[86]

In some ways, Ernesto's experience was a replay of that incident in Jesus' ministry as recorded in Matthew 26. When we genuinely love Christ, we want to give to him as generously as possible. We want to give him our first, our finest, and our best.

ERNEST D. STANDERFER

———◄•●•►———

Matthew 26:28 Blood (Lord's Supper)

In the fall of 1945, Ernie Pyle, famous war correspondent during World War II, was returning home from France on a ship that carried one thousand wounded American soldiers. About a fourth of them were terribly wounded, stretcher cases. Others were able to walk, although many had lost legs, arms, and eyes.

One hospitalized soldier was near death. He was wounded internally, and the Army doctors were trying desperately to keep him alive until they got to America. They kept giving him plasma and whole blood until they ran out of the whole blood. Doctors quietly

went about the ship typing blood specimens in search of suitable blood donors. They didn't want to make an announcement that a dying soldier needed blood because there would have been a stampede to the hospital ward by the other wounded men, offering their blood to this dying comrade. "Think of that," said Ernie Pyle, "a stampede of men themselves badly wounded, wanting to give their blood!"[87]

He, who "was wounded for our transgressions," said, "For this is my blood of the new testament, which is shed for many for the remission of sins" (Matt. 26:28). And by his blood we are healed.

JACK GULLEDGE

Matthew 26:30 The Lord's Supper

The words "They sang a hymn and went out" (TEV) are intriguing. As we study the worship patterns of Judaism, we learn that singing was a very basic part of the Passover meal. Jews came together to remember that time in their history when God had delivered them from their enemies in Egypt. Passover literally meant the time when the death angel had passed over them and touched the Egyptian babies that died. It was this last punishment or plague that came at the end of a long, tortured struggle that helped to set the people free. So annually the Jews gathered for Passover celebration—a time of remembering what God had done for them back in Egypt. At every celebration, they sang a hymn. They sang from the Hallel—Psalms 113-118. We now think they sang Psalms 113-114 before the meal and Psalms 115-118 after the meal. But these were all hymns of praise. They sang out of their rich memories and history to the glory of God.

What are we to sing as we leave the Lord's table and go out into the world? Like our spiritual forefathers long ago, we lift up a praise to God. We remember, in the singing, his goodness and his love. And, like them, we make our way back into the world peculiarly conscious that we are kept by a love that will not fail.

ROGER LOVETTE

Matthew 26:36-44 Sacrifice

In the earliest days of our country, George Washington attempted to direct a small force of men against various groups that were attacking isolated homesteads. Survivors of burnings and scalpings often came to his headquarters.

"The supplicating tears of the women and moving petitions of the men," Washington cried out, "melt me into such deadly sorrow that I solemnly declare, if I know my own mind, I could offer myself a willing sacrifice to the butchering enemy provided that would contribute to the peoples' ease. . . . If bleeding, dying! would glut their insatiate revenge, I would be a willing offering to savage fury, and die by inches to save a people."[88]

Facing the prospect of the cross, Jesus struggled with the options of his future. In his "thy will be done," he willingly offered himself "to save a people."

ERNEST D. STANDERFER

Matthew 26:36-46 Gethsemane

Following the fall of France in 1940, the German Third Reich claimed victory in Europe. Hitler appealed to Great Britain, "I am the victor, I can see no reason why this war need go on." Lord Hallifax officially responded that no peace would be acceptable to Britain which left Germany in control of non-German territory. However, the real reply had come a few weeks earlier, as Winston Churchill anticipated the fall of France. Churchill noted "the battle of France is over, I expect that the battle of Britain is about to begin. Upon this battle depends the survival of Christian civilization, . . . let us therefore brace ourselves to our duties and so bear ourselves that if the British Empire and its Commonwealth last for a thousand years, men will say, this was their finest hour."[89] This was 1940. Months of hardship, pain, destruction, and death were to follow, yet it was in the midst of aloneness and struggle that the decision was fixed. The English people faced their destiny with a sense of resolve.

It is always the finest hour when some struggle in behalf of the

good of others. But the supreme finest hour was Gethsemane. "Father,
. . . not as I will, but . . . thy will be done."

JAMES M. PORCH

Matthew 26:42 Adequacy

One of the lasting stories of heroism from World War II is the
story of the four chaplains, of differing faiths, who plunged to their
deaths on the night of February 3, 1943, when the U.S.S. *Dorchester*
was torpedoed by an empty submarine in the North Atlantic.

One of the four was Clark Poling, who, just before sailing, told
his father, Daniel A. Poling, also a clergyman, "Just pray that I shall do
my duty. Pray that I shall have the strength and courage and
understanding of men, and especially pray that I shall be patient. Oh,
Dad, just pray that I shall be adequate."

When disaster struck, and it became apparent that some troops
had no life jackets or were too terrified to put them on, Poling and
three fellow chaplains removed and shared theirs.

Then, joining hearts and hands in prayer, they went to their
deaths.[90]

Young Poling did not ask his dad to pray that he would come
home safe—only that he would be adequate. His prayer was answered.
In Gethsemane, Jesus prayed that God's will might be done, regard-
less. God did not deliver his Son from death but did make him
adequate for the cross. Too often, we pray for safety and "success" when
the better prayer is for strength to be adequate for whatever life brings.

ROBERT J. HASTINGS

Matthew 27:11-14 Jesus Before Pilate

When Kagawa, the great Japanese Christian, spoke at Princeton
Theological Seminary, he was beset by the wear and tear of sacrificial
service. His health was failing, and his eyesight was nearly gone. He
spoke a simple message with an unsteady voice; it was given through an

interpreter. At the conclusion of the service, as the crowd filed out of the chapel, a young divinity student commented to a classmate, "He didn't say much."

An elderly lady in attendance heard the comment and replied, "A man on a cross doesn't have to say anything."

The silence of Jesus before Pilate becomes a resounding message from the cross.

W. WAYNE PRICE

Matthew 27:27-37 The Cross

A popular monk in the Middle Ages announced that in the cathedral that evening he would preach a sermon on the love of God. The people gathered and stood in silence, waiting for the service to begin. As they waited, the last rays of sunlight streamed through the beautiful windows. As the last bit of color faded from the windows, the old monk quietly went to the candelabrum, took a lighted candle, and walked to a life-sized statue on the cross. Slowly and carefully he held the light until it shown on the wounds of the feet. Then he held the candle close until the hands were illuminated and then the bleeding side. Then, without a word, he let the light flicker on the thorn-crowned brow. That was his sermon.

It is said that the people stood in silence and wept, knowing they were at the center of a mystery beyond their knowing. Indeed, they looked at the love of God—a love so deep, so wide, so eternal that no words could fully express the measure of it all. We are on holy ground we come close to the cross of Jesus.

ROGER LOVETTE

Matthew 27:35 Atonement

When I was nine years old, I joined the YMCA in the summer. One of my friends who lived about a block or two away went with me three days a week to the "Y" to play and to swim. A little bus ran right in front of my house. The bus connected with the trolley line that took

us to town. So each time we went to the "Y," we were given enough money to ride the bus to the trolley and then to town and back home again.

One day my friend's mother gave him an extra dime and told him that we could get something refreshing to drink after we left the "Y." It seemed that session would never end. As soon as we had completed the swimming period and dressed, we hurried to the Walgreens drugstore on the corner. We climbed up on the stools at the lunch counter in that cool, air-conditioned store and prepared to give our order. Then we looked at the wall behind the counter and saw those pictures that some master artist had painted, depicting the various choices for food and refreshment available.

One thing particularly took our eyes—a chocolate ice-cream soda. Neither of us had ever had a chocolate ice-cream soda. We had no idea what they cost. If there ever was a case of "oversell," that was it. We were convinced that our day would not be complete without a chocolate ice-cream soda. So we each ordered one.

The sodas lived up to our expectations. I do not think I ever had anything quite so good. Then the waitress brought our ticket. When we looked at the ticket we nearly died! The place suddenly got hot. Our appetites suddenly vanished. The sodas turned sour. The ticket was for fifty cents, and all we had was ten cents. I could just see myself washing dishes all night long at the Walgreens drugstore to pay that ticket. We did not have any idea what to do.

Then, just when we had sunk to our lowest, a man who had been flirting with the waitress reached between us, picked up the ticket, and said, "That's all right, boys. I'll take care of this." And some unknown benefactor, whom we had never seen before nor since, paid our debt and rescued us. On the cross, Christ paid our debt and provided atonement for our sin.

JAMES E. CARTER

Matthew 28:1-10 Resurrection: Victory Over Death

Thomas Becket, twelfth-century archbishop of Canterbury, was murdered in his cathedral in 1170, following a long conflict with the

king. Many poems, stories, and plays have been written about Becket and his death. T. S. Eliot's account is a play called *Murder in the Cathedral.* In the final scene, the murderers approach the church, the doors of which have been barred by the assistants to the archbishop. Becket orders them to unbar the doors. He will not permit the house of prayer, the sanctuary, the church of Christ to be made a fortress. They plead with him at least to protect himself as he would against even a wild beast. But Becket refuses on the ground that he has no need to fear even death. He shouts victoriously that in the triumph of the cross, the beast has been defeated. He commands his assistants to unbar the doors.[91]

The resurrection is about the victory of the cross over the power of death. It is the account of the banishment of fear and the grounds for courage. Those who receive the power of the cross, as the basis for faith, are able to demand that the doors be unbarred. Death is no longer the enemy.

W. WAYNE PRICE

Matthew 28:1-11 Victory of the Cross

From the battle of Waterloo, there comes an interesting story. The news about the battle was brought by a ship sailing off the south coast of England. Then it was signaled to the capital. One of the signalers was on the roof of Winchester Cathedral, and, having received the message, he signaled to the next station the words "Wellington defeated . . . " He could get no further with the message because a fog closed in, and the signal could not be seen. When the message reached London, it plunged the whole city into gloom. Then the fog lifted and the signal from the cathedral could be seen again. This time the message was completed: "Wellington defeated the enemy." The mood of England was changed from gloom to ecstatic joy.

The story of the cross spelled gloom to the disciples. Only when the message was completed with Jesus' resurrection was the cross good news.

HAROLD T. BRYSON

Matthew 28:6 Resurrection

Across the street north of the ancient wall of Old Jerusalem is a pockmarked hill that many say is Golgotha. On the other side of the hill is a garden with a tomb which may be the tomb in which Jesus was buried.

A tourist entered the tomb, which is a small cave carved into a rock cliff. He was impressed by its stark emptiness. As he stepped from the darkness back into the sunlight, he lifted his hand as though making an announcement to the world and said loudly, "He is risen; he is not here."

A few days later that tourist and his wife attended a Baptist worship service in Jerusalem where most of those present were Christian Jews. The man and his wife were both greatly moved by the spirit and participation in the service.

He whispered to her and repeated what he had said at the tomb with a slight change: "He is risen, and he is here!"

ELMER L. GRAY

Matthew 28:19 Power

On Saturday, October 4, 1964, hurricane Hilda struck Baton Rouge, Louisiana. The winds reached in excess of 150 miles per hour. The devastation of the city was awesome. Over seventy-five thousand homes were without electrical power.

I went to our church early Sunday morning to survey the damage. Even though the church had twelve-inch-thick brick walls, the force of the wind had blown water through the walls of the church. Several windows had been blown out. The church was a mess, to say the least. In addition, the electricity was off.

I returned to our home and called the radio station to ask them to announce cancellation of our services. When the person at the radio station answered the phone, I asked him to announce that University Baptist Church had canceled its services because of power failure.

After I hung up the phone, I turned on the radio to listen for the

announcement. They gave it exactly as I had given it to them: "University Baptist Church has canceled its services today because of power failure."

The words suddenly struck home. Was I a prophet speaking words of truth or a pastor making an announcement? Jesus said, "All power is given unto me." I was forced to ponder Jesus' words. Is the condition of our world today mute testimony that we have not claimed this promise of our Savior?

JAMES A. YOUNG

Matthew 28:19-20 Presence

When David Livingston had completed the second of his several tours in Africa, he met with Queen Victoria. Then he was asked to Cambridge to lecture in the assembly where normally a speaker received jeers. There was nothing but silence as he spoke. Then he was asked, "Mr. Livingston, what was it that kept you going all the time that you were in the dark continent?"

He answered, "What kept me going in that dark continent was the words of the gentleman called Christ who said, 'Lo, I am with you alway, even unto the end of the world.'"

HAROLD T. BRYSON

Matthew 28:19-20 Missions

A young minister, according to H. H. Hobbs, asked a successful military leader how he could be as successful in the ministry as the military genius was in the field.[92]

The general asked, "What are your marching orders?"

The young preacher replied by quoting the Great Commission: "Go ye therefore, and teach all nations, baptizing them in the name of the Father, and of the Son, and of the Holy Ghost: Teaching them to observe all things whatsoever I have commanded you: and, lo, I am with you alway, even unto the end of the world."

The great general asked, "Well, what are you waiting for?"

The secret of success for Christians is to do what Christ has commanded. Our goal can be nothing less than winning the world to the Lord. Do we feel too small for our task?

Alexander the Great crossed from Europe into Asia Minor with just over thirty thousand men to attack the Persian Empire, which had armies totaling over half a million. He and his Macedonian warriors fought their way boldly southward into Egypt and eastward to India. They conquered their world and changed it for all time to come.

What a day this would be for Christ if those who call him Lord would boldly witness for him to every person in this world. It would change human history for all time to come.

ELMER L. GRAY

Matthew 28:19-20 Witnessing

"Several years ago I pastored in Atlanta, Georgia. I went by one day to visit a lady who had sent her child to our Mother's Day Out program. I wanted to talk to her about the Lord and seek to involve her in our church. She and I had been visiting only a few minutes when her husband came home from work. As he walked into the room, she stood up and said, 'Honey, this is the pastor from the Woodland Hills Baptist Church. He came to talk to you about God!' Then she walked out of the room.

"Rather awkwardly, we sat down and began to talk. It was as if a dam broke and all of the desires and needs and hurts of his soul came pouring out. For over an hour he talked about what he was and what he wanted to be. He talked about his needs, about his emptiness, about his hunger, about his fears. When he had talked himself out, I shared with him how Christ could meet his needs. That afternoon, we kneeled in his living room as he invited Christ to come into his heart."[93]

I have had many other experiences like that over the years. The factor that made this particular experience stick in my mind was what the man said right before I left his home. "Preacher," he said, "I've been waiting five years for someone to help me get straightened out with God."

Jesus had people like that man in mind when he said, "Go therefore and make disciples of all nations, baptizing them in the name of the Father and the Son and the Holy Spirit, teaching them to observe all that I commanded you" (Matt. 28:19-20, RSV). If we don't go to them, who will?

BRIAN L. HARBOUR

———————◄●●►———————

Matthew 28:19-20 Evangelism

A mother sent her boys out to play and noticed they were digging a large hole. Later she overheard their conversation with some older boys who had come to watch. The little fellows explained that they were digging a tunnel to China. The older boys began to laugh, telling the younger ones that their task was impossible. After a long silence, one of the diggers picked up a plastic container full of ants, worms, and beetles. He removed the lid and showed the wonderful contents to his detractors. He said quietly and confidently, "Even if we don't dig to China, look what we found along the way!"[94]

Jesus' command that his followers tell all the world the good news is indeed, an awesome task, one that may never be completed. But in the process of obedience to that command, his followers will find many wonderful people along the way. The magnitude of the task and the goal itself should not cause us to miss the wonders of the people along the way.

W. WAYNE PRICE

Notes

1. J. Dixon Free, *Proclaim,* January 1982, pp. 44-45.
2. George E. Sweazey, *Preaching the Good News* (Englewood Cliffs, New Jersey: Prentice-Hall, Inc., 1976), p. 194.
3. Andrew W. Blackwood, *The Preparation of Sermons* (Nashville: Abingdon Press, 1948), p. 159.
4. L. D. Johnson, *Moments of Reflection* (Nashville: Broadman Press, 1980), pp. 139-140.
5. Adapted from a story in the *Nashville Banner,* Nashville, Tennessee, June 24, 1981.
6. Sam Keen, *To a Dancing God* (New York: Harper & Row, 1970), p. 100.
7. *Newsweek,* August 17, 1981, p. 60.
8. Harry S Truman, "From Mr. President to Mr. Citizen," *Reader's Digest,* August 1960, p. 192.
9. W. T. Conner, *The Faith of the New Testament* (Nashville: Broadman Press, 1940), p. 169.
10. E. Stanley Jones, *Victory Through Surrender* (New York: Abingdon Press, 1966), pp. 8-9.
11. George B. Shaw, *Back tó Methusaleh* (London: Constable & Co., 1931), p. 12.
12. Ralph W. Sockman, *The Whole Armor of God* (Nashville: Abingdon Press, 1952), p. 15.
13. Timothy Rice, *Jesus Christ Superstar* (London: Leeds Music, Ltd., 1969), p. 16.
14. Albert Schweitzer, *The Quest of the Historical Jesus* (London: A & C Black, Ltd., 1922), p. 401.
15. Sydney Harris, "Happiness in One's Life Is Really Just a Spin-off," *Detroit Free Press,* Detroit, Michigan, October 1, 1981, p. 13B.
16. Quoted in Robert J. Hastings, *Take Heaven Now!* (Nashville: Broadman Press, 1968), pp. 21-23.
17. Ibid., p. 35.
18. Daphne du Maurier, *Reader's Digest,* August 1980, pp. 72-74.
19. Omar Bradley, *Guideposts,* May 1949, pp. 12-13.
20. Philip P. Bliss, "Let the Lower Lights Be Burning," *Baptist Hymnal* (Nashville: Convention Press, 1956), No.300.
21. Clarence Jordan, *Cotton Patch Version of Matthew* (New York: New York Association Press, 1970), pp. 22-23.
22. William Shakespeare, *Macbeth,* Act I, Scene 5.
23. Gerald H. Kennedy, *Have This Mind* (New York: Harper & Brothers, 1948), p. 210.
24. Carl Bates, "Pastor's Column," *The Church Voice,* First Baptist Church, Charlotte, North Carolina, July 15, 1965.
25. Allen Dixon, *Reader's Digest,* November 1977, p. 136.
26. Oren Arnold, *Reader's Digest,* October 1971, p. 83.
27. George Buttrick, Message at Pastor's Conference, Georgetown College, Georgetown, Kentucky, 1970.
28. Joe Ingram in *The Baptist Messenger,* August 10, 1981, p. 9.
29. Kennedy, p. 165.
30. Peter Smith, *The Journal of John Woolman and a Plea for the Poor* (Secaucus, New Jersey: Citadal Press, 1972).

31. *The Baptist Messenger*, August 3, 1981, p. 9.

32. Bill Keane, "The Family Circus" (The Register and Tribune Syndicate), *The Courier-Journal*, Louisville, Kentucky, September 9, 1981.

33. Myron Augsburger, *The Expanded Life* (Nashville: Abingdon Press, 1972), p. 103.

34. Adapted from *Reader's Digest*, March 1974, p. 86.

35. William Barclay, *Spiritual Autobiography* (Grand Rapids: Eerdmans, 1975), p. 45.

36. Bob Cunningham, "Declaration Signers Were Hunted Men in Next Seven Years," *Knoxville News-Sentinel*, Knoxville, Tennessee, July 4, 1965.

37. Amsterdam Synagogues' curse on Spinoza in *Barlett's Familiar Quotations*, Centennial Edition (Boston: Little, Brown and Company, 1955), p. 281.

38. Elizabeth Yates McGreal, *Howard Thurman* (New York: John Day Co., 1964), p. 101.

39. Adapted from Ruth and Edward Brecher, "Footprints on the Sands of Time," *Reader's Digest*, January 1945, p. 97.

40. Blaise Levai, *Bible Society Record*, December 1964, p. 153.

41. Will and Ariel Durant, *Interpretations of Life: a Survey of Contemporary Literature* (New York: Simon and Schuster, 1970) pp. 43,25,48,61.

42. *Asheville Citizen-Times*, September 6, 1981, p. 10A.

43. Herschel H. Hobbs, *An Exposition of the Gospel of Matthew* (Nashville: Broadman Press, 1977), p. 144.

44. Joseph Lash, *Helen and Teacher: The Story of Helen Keller and Anne Sullivan Macy* (New York: Delacourt Press, 1980), p. 52.

45. J. Winston Pearce, *Broadman Comments*, 1964-1965 (Nashville: Broadman Press, 1964), pp. 281-282.

46. Adapted from *Reader's Digest*, March 1947, p. 33.

47. William Barclay, *In the Hands of God* (New York: Harper & Row, 1967), p. 65.

48. Adapted from *Reader's Digest*, August 1980, pp. 24-28.

49. From a plaque located in the visitors' center at the Abraham Lincoln Birthplace, National Historical Site, near Hodgenville, Kentucky.

50. "Thomas A. Edison," *World Book Encyclopedia*, Vol. E (Chicago: World Book-Childcraft Internation, 1961), pp. 49-50.

51. *Knoxville News-Sentinel*, Knoxville, Tennessee, June 15, 1981.

52. Shaw, p. 14.

53. *The Christian Century*, August 12-19, 1981, p. 802.

54. Eberhard Bethge, *Dietrich Bonhoeffer* (New York: Harper & Row, 1977), p. 833.

55. Antoine de Saint Exupéry, *The Little Prince* (New York: Harbrace Paperback Library, 1943), pp. 3 f.

56. A. Leonard Griffith, "Cheating the Children," *The City Temple Tidings*, July 1965, p. 169.

57. Fred Craddock, *Overhearing the Gospel* (Nashville: Abingdon Press, 1978), pp. 93-94.

58. Trina Paulus, *Hope for the Flowers* (New York: Paulist Press, 1972), see chs. 1-5.

59. Adapted from Isaac Asimov, "Never Again Lost," *American Way*, June 1981, pp. 13-14.

60. Fawn M. Brodie, *Thomas Jefferson: An Intimate History* (Toronto: Bantam Books, 1974), p. 606.

61. G. Curtis Jones, *Pulpit Digest*, July-August 1964, p. 32.

62. Ralph L. Murray, *The Other Dimension* (Nashville: Broadman Press, 1966), pp. 63-64.

63. Jim Vaus, *The Devil Loves a Shining Mark* (Waco: Word Books, 1974), pp. 60-61.

64. Irving Stone, *Love Is Eternal* (New York: Doubleday & Co., Inc., 1954), p. 459.

65. William Shakespeare, *Merchant of Venice*, Act IV, Scene 1.

66. *Daily Press*, Newport News, Virginia, August 31, 1981.

67. Adapted from Suzanne Britt Jordan, "Married Is Better," *Newsweek*, June 11, 1979, p. 27.

68. Barbara Myerhoff, *Number Our Days* (New York: Simon and Schuster, 1978) pp. 47-48.

69. William Shakespeare, *Hamlet, Prince of Denmark,* Act III, Scene 3.

70. Viktor Frankl, "How a Sense of a Task in Life Can Help You Over the Bumps," *The National Observer,* July 12, 1951, p. 22.

71. Adapted from *Reader's Digest,* December 1976, p. 135.

72. James Thomas Flexner, *Washington: The Indispensable Man* (Boston: Little, Brown, and Co., 1969), p. 174.

73. Adapted from "American Observer," *American Way,* June 1981, p. 8.

74. *The Interpreter's Dictionary of the Bible* (New York: Abingdon Press, 1962), R-Z, p. 321; K-Q, pp. 808, 368.

75. *Broadman Bible Commentary,* Vol. 8 (Nashville: Broadman Press, 1969), p. 209.

76. Steven M. Panko, "Martin Buber" in *Makers of the Modern Theological Mind* (Waco: Word Books, 1976), p. 44.

77. T. S. Eliot, *Murder in the Cathedral* (New York: Harvest Books, 1963), p. 44.

78. Myerhoff, p. 80.

79. Roy O. McClain, *This Way, Please* (Westwood, New Jersey: Fleming H. Revell Co., 1957), p. 166.

80. Adapted from "The Doomsday Boom," *Newsweek,* August 11, 1980.

81. *The Baptist Messenger,* September 10, 1981, p. 5.

82. William Shakespeare, *Julius Caesar,* Act IV, Scene 3.

83. Isser Harel, *The House on Garibaldi Street* (New York: The Viking Press, 1977), cover.

84. *Knoxville News-Sentinel,* Knoxville, Tennessee, August 23, 1981.

85. Adapted from *The Courier-Journal,* Louisville, Kentucky, September 24, 1978.

86. A. Clark Scanlon, "A New Dimension of Joy," Stewardship Sermon of the Month, *Baptist Program,* May 1975.

87. Adapted from Ernie Pyle, "Challenge to Civilians," *Reader's Digest,* January 1945, p. 34.

88. Flexner, p. 30.

89. Abraham Rothberg, *Eyewitness History of World War II* (New York: Bantam Books, 1971), pp. 10-12.

90. *Modern Maturity,* April-May, 1981, p. 4.

91. Eliot.

92. Hobbs, p. 422.

93. Brian Harbour, *Famous Singles of the Bible* (Nashville: Broadman Press, 1980), p. 91.

94. Adrienne Popper, "Digging to China," *Parents,* July 1981, p. 64.

Index